IMAGES
of America

STILLWATER

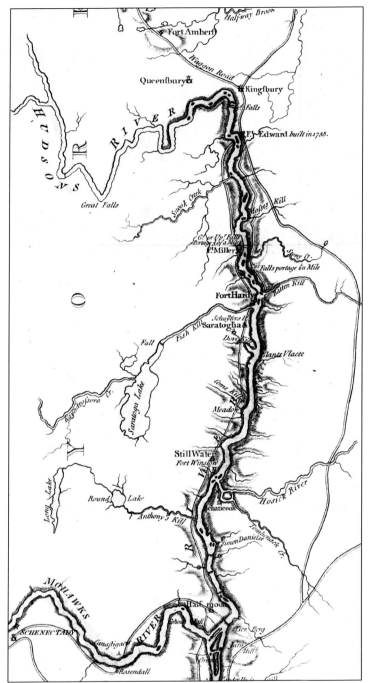

This 1779 map shows the province of New York. Note that Stillwater is shown along with Fort Winslow, the outpost that was here at the time of the battles of Bemis Heights and Freeman's Farm. The fort was built in 1756 by Gen. Fitz John Winslow on the site of the decaying Fort Ingoldsby. There is a historical marker noting this spot. (Courtesy of the Stillwater Historian's Office.)

On the cover: Please see page 75. (Courtesy of the Stillwater Historian's Office.)

IMAGES
of A m e r i c a

STILLWATER

Linda Sanders

ARCADIA
PUBLISHING

Copyright © 2009 by Linda Sanders
ISBN 978-0-7385-6356-5

Published by Arcadia Publishing
Charleston, South Carolina

Printed in the United States of America

Library of Congress Control Number: 2008936588

For all general information contact Arcadia Publishing at:
Telephone 843-853-2070
Fax 843-853-0044
E-mail sales@arcadiapublishing.com
For customer service and orders:
Toll-Free 1-888-313-2665

Visit us on the Internet at www.arcadiapublishing.com

*This book is dedicated to everyone who has ever lived,
lives, or will live in this wonderful town.*

CONTENTS

ACKNOWLEDGMENTS

There are several people who have assisted with this book. Most of all, thanks to the late May Edwards, Susan Hayner, and Elizabeth Abel, who preceded me as Stillwater historian. Special thanks also go to the residents of Stillwater who graciously donated artifacts to the office to help preserve our history.

To Linda Palmieri, the town historian and special friend, who continually supported me in this effort; Jessica Dunn and Michael Hipwell, who did the typing; and also Timothy Campbell, who helped so much with the technical end of this publication.

Unless otherwise indicated, all images are courtesy of the Stillwater Historian's Office.

INTRODUCTION

Stillwater was on the highway of history long before 1788. It was strategically situated at the joining of two rivers, the Hudson and the Hoosac, which made a natural crossing place for Native Americans as they went to their summer hunting grounds and later on for the King's Highway between Albany and Montreal. Hunters and traders also knew the trail up the Hudson River very well.

The "Place of the Still Waters" was known as an early settlement. French people were here in the early 1600s and are known to have a mill, but they had to go to Albany to baptize their children in the Catholic faith.

Soldiers used the highway during the drawn-out French and Indian War. The early Fort Ingoldsby (1709) and its successor, Fort Winslow (1756), gave them shelter and protection on their journeys to and from Canada.

With the signing of the treaty of peace in 1759, pioneer homesteaders took the route of the ammunition wagons. In 1762, a Congregational church society from Connecticut, with their pastor, Rev. Robert Campbell, settled in the southern part of the town near the joining of the Hudson and Hoosac Rivers. At about the same time, Baptists from Rhode Island settled in the northern section near Munger Hill. In 1764, 200 Scotch-Irish Presbyterians were overtaken by winter here on the way to Lake George. They were hospitably taken in by the residents of Stillwater and Schaghticoke, where they stayed for two years until a purchase of lands could be arranged in a less-rigorous climate than Lake George. They became early settlers of Salem, New York.

Stillwater village grew quickly from a struggling outpost into a market center for the northern settlement along the river, with inhabitants in the lakes region and others to the east. At the outbreak of the Revolutionary War, gristmills, sawmills, a tannery, an ashery, a fuller's works, a brewery, a brick kiln, and stores and saloons made a thriving settlement.

In 1775, a request was made to patriot George Palmer for sleds to take the cannon from Ticonderoga to Boston. On Christmas Eve, Col. Henry Knox arrived at the home of Ezekiel Ensign. Because of a snowstorm, Knox was forced to stay in Bemus Heights until the following day.

As the communities were threatened, families were sent to Albany or back to New England for safety, and the men faced the British.

The British were defeated at the Battles of Bemis Heights and Freeman's Farm in 1777 in Stillwater. Together, the two are rated as the 13th most important battle of the world. It is now the site of the Saratoga National Historical Park. The battles, however, left desolation in

their wake; buildings were burned, cattle were confiscated, and crops were wiped out. Returning residents had to start all over again and needed to be alert at all times for attacks from Native Americans or Tories.

At the beginning of the 19th century, progress and prosperity began. Stillwater, along with Halfmoon, Saratoga, and Balls Town became official towns of Saratoga District in Albany County on March 7, 1788. The first board of supervisors meeting was held at Mead's Tavern shortly afterward. In 1791, Saratoga County was formed, and Stillwater became known as one of the mother towns.

The Northern Inland Lock Navigation Company was started by Gen. Philip Schuyler in 1793. This was known as Schuyler's Ditch. Work began near Stillwater and was to proceed to Waterford. The company failed, and later in 1823, the Champlain Canal was opened, and the golden age of commerce and transportation began.

There were several stores, inns, mills, and barns for the changing of the horses and mules that towed the barges. These towpaths are still visible in Stillwater.

The year 1816 was key in Stillwater's history. Aside from the fact that it is known as the "year without a summer," it also stands as a milestone in the growth of the village of Stillwater as the year a hamlet by the river received its charter, on April 17, 1816.

During this period, Stillwater produced congressmen, presidential electors, members of the assembly, and judges. A Stillwater girl named Abigail Powers, daughter of Elder Lemuel and Abigail Newland Powers of the First Baptist Church, became the wife of Millard Fillmore, the country's 13th president.

The town was an educational and commercial center and had an academy, which flourished for many years. In 1824, there were more sheep than people, and it had 498 dwellings, 13 district schools, and 1,046 working oxen and cattle. In addition to all the mills and industries, farming was very important. In 1860, local farms produced 101,935 pounds of butter and 13,090 pounds of cheese.

However, progress caught up with Stillwater and then bypassed it. The canal was overtaken by the railroads, there were devastating mill fires, and stores dwindled or closed.

Stillwater has become a bedroom community, with people commuting to work in the nearby capital district. There is now a building boom, as the charm of the village, with its stately Victorian homes and its location by the river and rolling hills has been discovered.

Stillwater is a growing community with a population of 7,522 according to the latest census. Come and enjoy history at its best.

One

STILLWATER VIEWS

The emblem of the blockhouse has been used since the inception of the blockhouse committee. This logo was designed by Kathi Blinn, an original member of the committee. The committee began in November 1991 to find a way of moving this building to the new park in the village. A group of 13 was formed from the residents of both the town and village of Stillwater.

The town of Stillwater was first settled in 1760 by Isaac Mann, who built a mill on the Hudson River. Later in 1762, a group of Congregationalists from near Canaan, Connecticut, and Baptists from Rhode Island also settled here. On March 7, 1788, Stillwater became an official town in Saratoga District in Albany County.

The town hall is located on West Street in the hamlet of Riverside. This building was originally school four in Mechanicville School District and was purchased for $5,000 in 1981. It was completely renovated and remodeled and is used as offices for the town clerk, supervisor, assessor, and court.

The village of Stillwater was formed from the town in April 1816. Early records have been lost, but the first recorded entry of 1821 shows that the first president was Elias Palmer. The mayoral system took place in 1928, and he was elected among the trustees. In 1952, the people elected the mayor for the first time. Prior to 1928, the president was elected from the board of trustees.

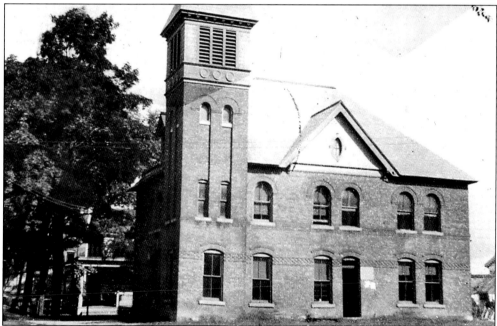

This building, located on School Street, is home of the Newland-Wood Fire Department. The area that was originally the home of the steamer was converted into the village offices in 1984. The village clerk, mayor, fire department, and a Saratoga County sheriff substation are located there.

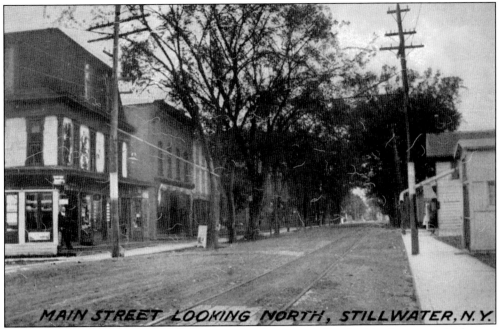

MAIN STREET LOOKING NORTH, STILLWATER, N.Y.

The postcard shows Main Street looking north. The street is lined with elm trees, which were later destroyed by Dutch elm disease. On the left, from left to right, are Hoskins Confectionary, Smodell Barber, and a millinery store. The next building is the William Palmer Funeral Parlor. These buildings are still in use and have not changed much in the past 100 years.

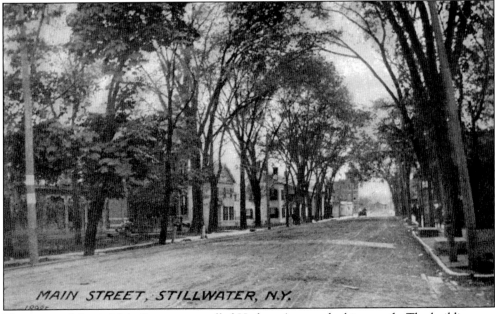

MAIN STREET, STILLWATER, N.Y.

This postcard shows Main Street, now called Hudson Avenue, looking south. The buildings on the east side of the street were mainly residential, with the exception of the Hewitt House. The trolley tracks in the middle of the street took many passengers to the neighboring communities north and south of Stillwater.

12

These two houses are mirror images of each other. They were built for Rial and Henry Newland in the mid-1880s. There are stories about theses houses and why they are called the twins, including that they were built for the Newlands' daughters. The Victorian style with wrap-around porches gives a palatial view of the Hudson River.

There was a brick building behind the twin houses that was used as a horse-and-carriage barn. David Newland, pictured here, was one of the owners of the twin houses. The home was later sold to Joshua Anthony, and he and is family lived there for many years. The barn was later converted into a print shop that was run by Ira Anthony.

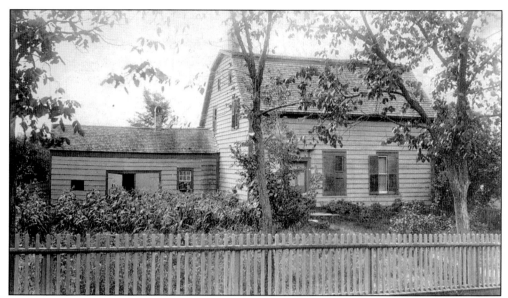

The Dirck Swart house is a Dutch Colonial farmhouse on North Hudson Avenue in the village. This house was built about 1760 and is one of the oldest homes in the community. Swart was one of the early settlers, and this home was also used as the headquarters for Gen. Philip Schuyler when he was the commander of the northern armies.

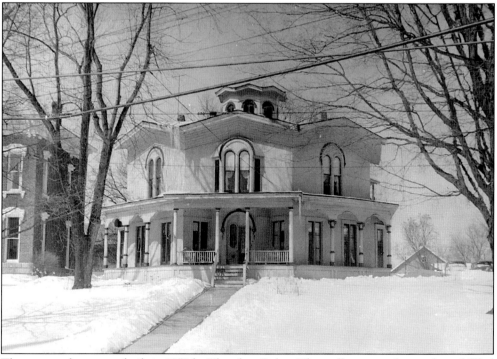

The octagon house was built in 1858 by Theodore Baker. The walls are one foot wide and filled solid with brick and mortar. A tree was used for a center post and an unusual circular staircase was hung on the tree of which the growth rings can still be counted at the top of the landing. It is still a residence, owned by Wayne and Brita Donovan.

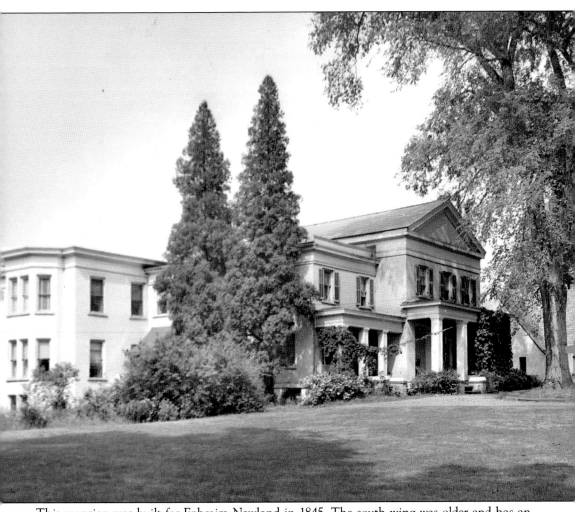

This mansion was built for Ephraim Newland in 1845. The south wing was older and has an interesting basement with reservoirs, an ice chamber, a kitchen, a fireplace, a meat room, and a battery with Dutch maple plank shelves. The home was later occupied by Dr. George Hudson and his family. After the doctor's death, it was used as a tourist home.

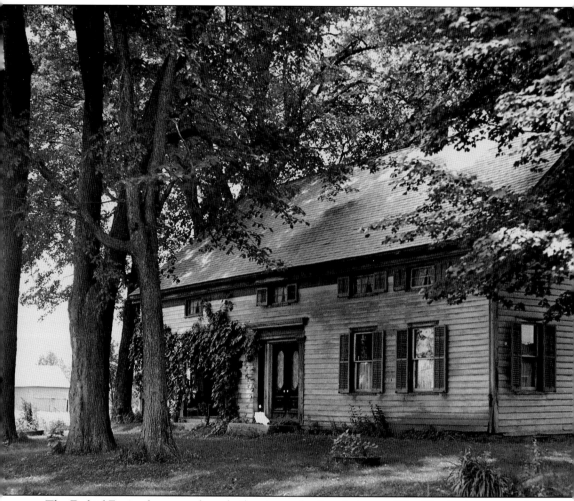

The Ezekiel Ensign homestead was built prior to the Revolutionary War. The back part was the oldest, original portion of the house. In 1775, Col. Henry Knox spoke on Christmas Eve here on his way with the cannon to Boston. The house was destroyed by fire in 1946. It was used as a hospital for the British during battles, and there were blood stains visible on the wooden floors.

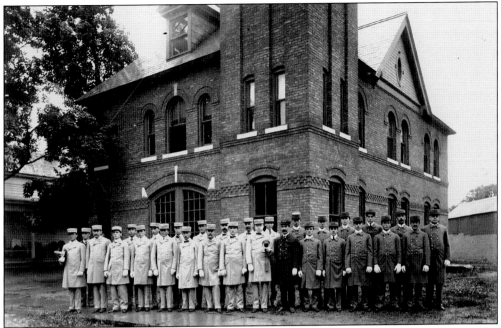

The E. I. Wood Steamer Company was formed in 1875 and known as Stillwater No. 1. The J. B. Newland Hose Company was formed about the same time. The photograph shows the two different colored uniforms of the E. I. Wood Steamer Company and the Newland-Wood fire company of the Stillwater Fire Department.

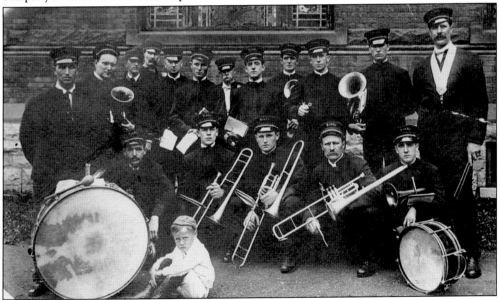

The Pemble Band was made up of local musicians and was know for its beautiful music. This picture was taken in 1908 with the Presbyterian church in the background. Pictured from left to right are (first row) Everett Hall, Arthur Collins, Raymond Dyer, Charles H. H. Dyer, and Lester Sharp; (second row) Earl H. Hayner, William Sparahawk, Ted Lloyd, William Bradley Sr., W. Shook, Charles Dyer Jr., W. Bryant, Archie Smodell, A. Rancourt, R. Coulson, Arthur Bradley, and Sam Bradley. Donald Sparahawk is in front.

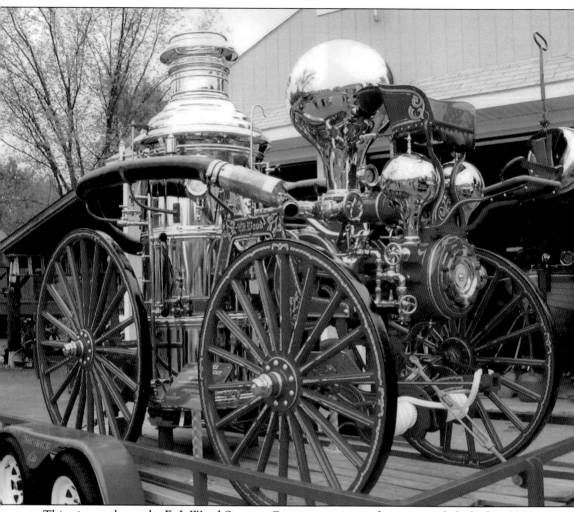

This picture shows the E. I. Wood Steamer Company steamer after it was refurbished in 2002. This steamer was purchased from the Button Company in Waterford in 1875. It was in use until the 1930s when the company became mechanized. The steamer was actually usable until 1963, when it was stored in a salt shed where it began to deteriorate. This steamer is brought to many parades and has won several awards.

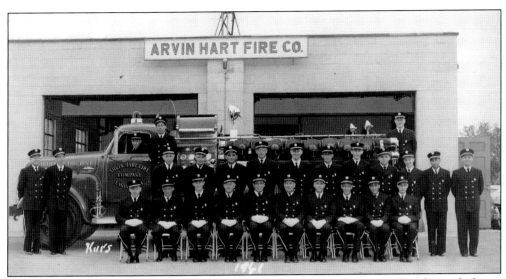

This photograph was taken in 1961 as the Arvin Hart Fire Company posed in front of what is now called Cowin Station, the main station on Campbell Road. Pictured from left to right are (first row) George Reilly, Raymond Brooks, Robert Patterson, James Hutton, Charles Schweder, Clarence "Mike" Payne, Walter Joba, Robert Scales, Thomas Vano, and William Sanders; (second row) Lawerence Rinaldi, Felix Farina, Donald Briggs, William Eaton, Peter Carriero, Guy Dunn, Robert Kussius, Henry Hutton, Royal "Herbie" Cowin, Andrew Miller, Edward Brooks, Richard Rourke, and Warren Schell; (third row) Walter Cowin (in the truck), Horton Girdler, and James Gannon.

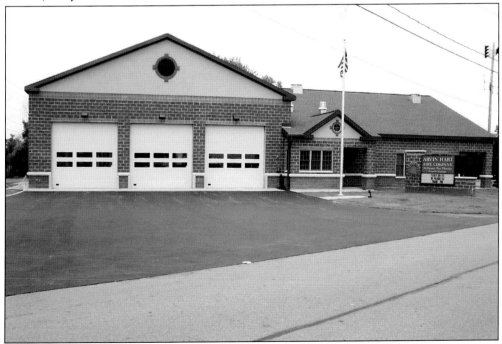

This is the new Arvin Hart Fire Company main station, called the Cowin Station. It was named after Charles and Pearl Cowin, who donated the land where the firehouse is located. This building replaced the original station that was built in 1954. It was completed in 2005.

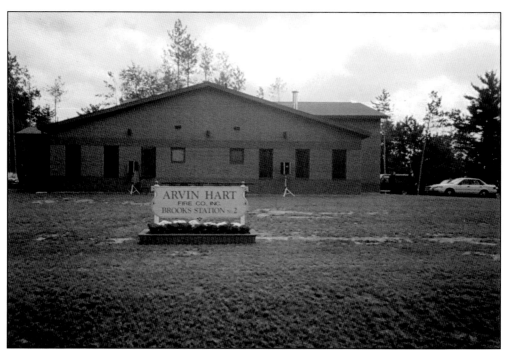

The Raymond Brooks Station is located on Farley Road near Luther Forest. The firehouse was named after a former fire chief who served for many years. He was truly a dedicated member of the fire company.

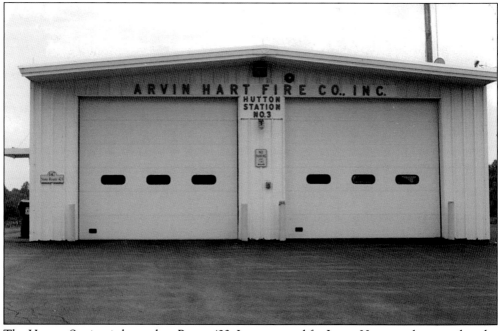

The Hutton Station is located on Route 423. It was named for James Hutton, who served as the first fire chief. He also served on the board of commissioners. This station was built in 1976. (Courtesy of Walter Ardiewicz.)

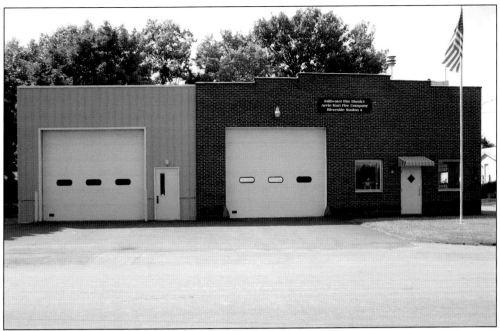

The Riverside Fire Department was first formed as a bucket brigade in the 1920s. This was the smallest fire district in New York State at the time. The department dissolved in 2001, and members then joined Arvin Hart Fire Company. While most fire stations are named after someone, it was decided to keep this as the Riverside Station.

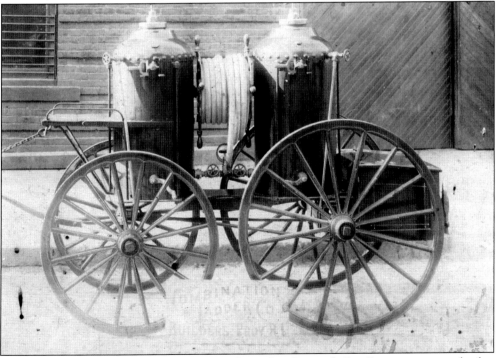

This picture shows an early fire hose and cart from when Riverside Fire Department was a bucket brigade. The residents of this hamlet took care of the needs of the area.

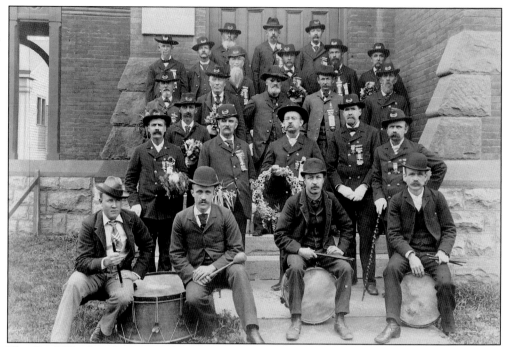

The Civil War found many residents either enlisting or being drafted into the army. A total of 200 Stillwater residents served at this time. Pictured are several of these men who served, mainly in the 77th New York Infantry Bemis Heights Battalion, named for Bemis Heights. The local GAR was named after Gilbert Thomas, a second lieutenant from Stillwater who was killed during the battle of Cedar Creek. Seen above, from left to right, are (first row) Edward Ford, Edward Whitman, George Whitman, and Charles Haight; (second row) John Britten, William Barnes, Robert Hayner, Robert Harcourt, John Bradley, and Edward Collamer; (third row) unidentified, Warren Golden, John Whitman, Walter Hewitt, and Emerson Tabor; (fourth row) Oramel T. Bostwick, unidentified, Sylvester Mason, unidentified, Sylvester Haight, and William Britten; (fifth row) William Overocker, John Van Wie, and Robert Parker.

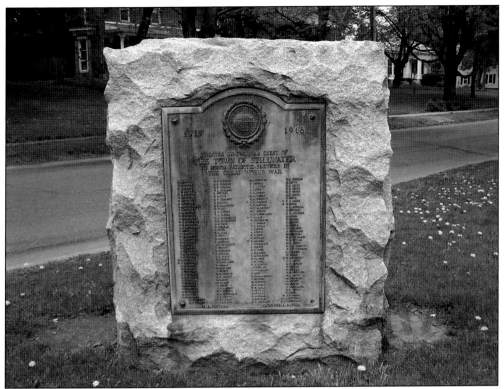

The World War I monument is located in Cannon Park on the corner of Park and Hudson Avenues. It was erected after the war and listed all who served. There is a star marking the name of Earl J. Manning.

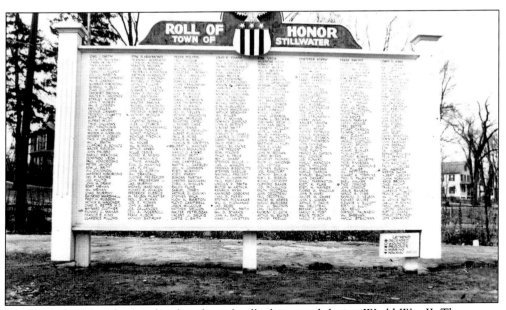

This was a wooden display that listed nearly all who served during World War II. The names included those from the hamlets in town. It was later removed, as it had fallen in disrepair.

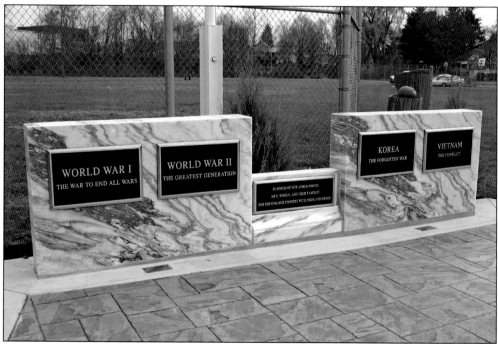

This is a portrait of Earl J. Manning, who died during World War I. The American Legion is named for him. He died in France and was returned to Stillwater where he was buried in Union Cemetery with full military honors.

This is the new memorial located on the ground of the Earl J. Manning Post No. 490. It was dedicated in November 2006 and honors all who have served the nation from the time of the Revolutionary War to the war in Iraq.

This is a picture of Henry J. Lefko, who was killed in World War II. The legion post in the hamlet of Riverside took his name, as he was a resident of the area. He is buried in France, and there are still members of his family living locally.

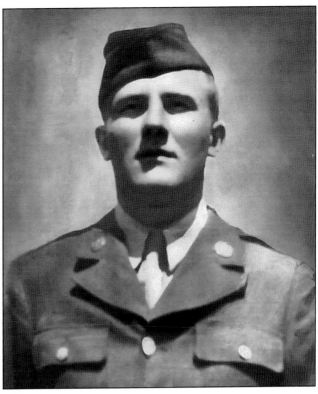

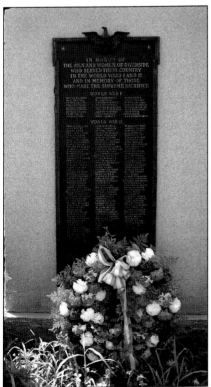

The Riverside monument was originally located on the banks of the Hudson River. It was moved to Riverside Park in the 1990s. Those who served the country from Riverside during World War I and World War II are listed here.

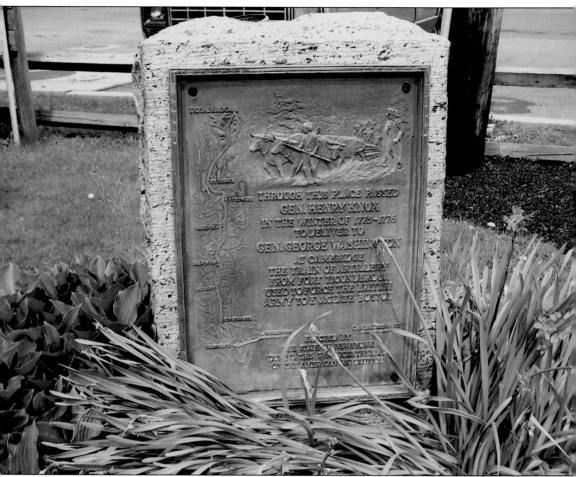

There are two Knox Trail Markers located in Stillwater. The one in the town is at Bemis Heights. The second, pictured here, is located in Cannon Park in the village. The plaques were recently refurbished by the state.

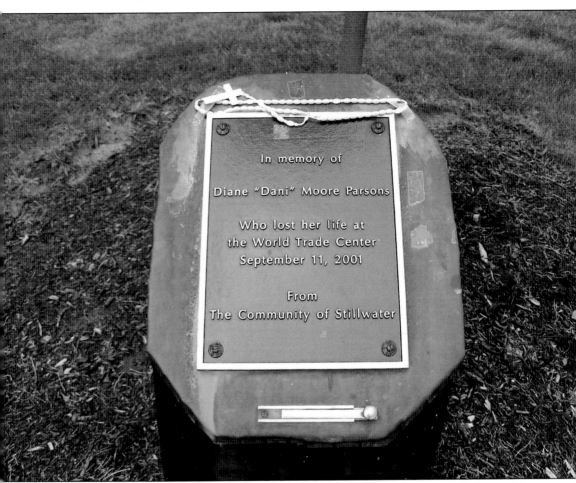

In memory of

Diane "Dani" Moore Parsons

Who lost her life at
the World Trade Center
September 11, 2001

From
The Community of Stillwater

On September 11, 2001, when tragedy struck this nation, a Stillwater resident was in one of the towers. Diane "Dani" Moore, a 1961 graduate of Stillwater Central School, was killed. The town erected this monument in her memory; she will always be remembered by those who knew her. She left two sons and a daughter.

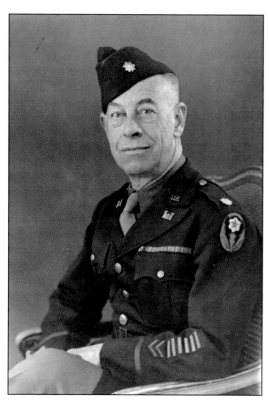

Col. George W. Martin of the U.S. Army Reserve was sent here in 1939 to open a Civilian Conservation Corps camp. This was the last camp to be erected in New York State. They worked at the Saratoga battle field, including the building of roads, especially to where the visitor center is now located. After his retirement, Martin returned and lived in Stillwater with his wife and daughter.

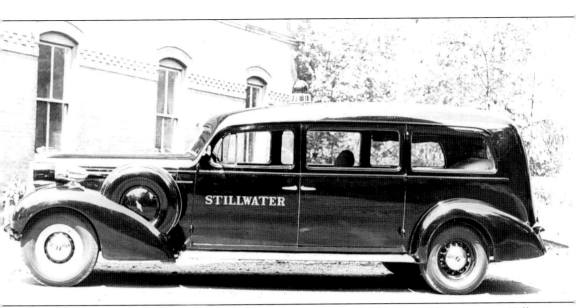

The need for an ambulance became a reality in 1952. Percy Aldrich and Fr. Lawrence Kelly purchased a hearse from Chester Hack. This was used for several years until funds were raised for another one. The first building that was used was at the fire department until the present building was purchased from the Gooley brothers in 1980. Improvements have been made, and now there are two ambulances to serve the community. A volunteer group is still in charge.

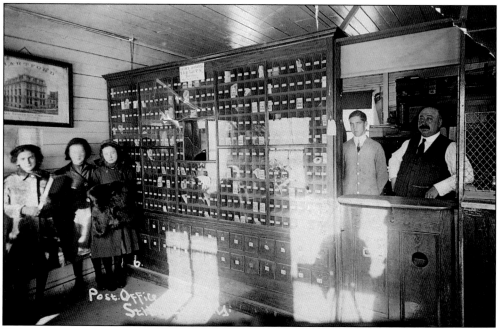

This is the site of the post office when Frank Stumpf, pictured here on the right, was the post master. Stumpf lived next door and was hired to keep an eye out for robbers. In 1913, there was a robbery and Stumpf positioned himself on an upstairs window. When the robbers had blown the safe open and tried to get away, Stumpf fired his shotgun, killing one of the robbers. He received a commendation from Washington. There was a rash of burglaries during this period.

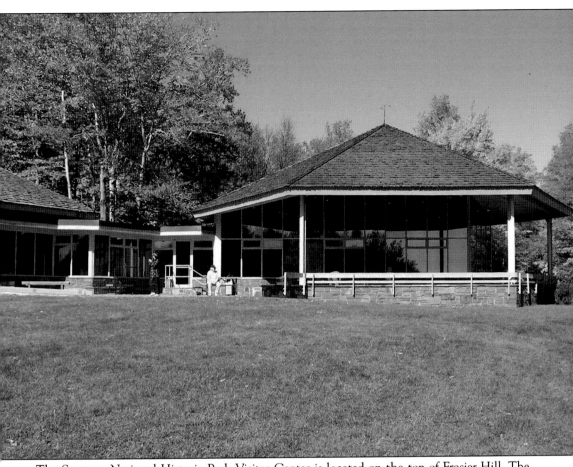

The Saratoga National Historic Park Visitor Center is located on the top of Frasier Hill. The spot was originally chosen by Pres. Franklin Roosevelt. Gen. Simon Frasier, second in command to Gen. John Burgoyne, was killed near here and supposedly buried near this spot.

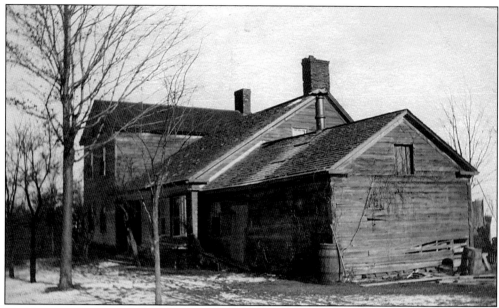

The Freeman farm was near the location of the first battle; the Freeman family were loyalists and served with Jessup Rangers during the war. Their lands were later confiscated, and they went to Canada to live. In 1883, the farm was sold to Hester Esmond, and members of her family lived there until 1916. It was sold to the Saratoga Battle Field Association in 1923 and later razed.

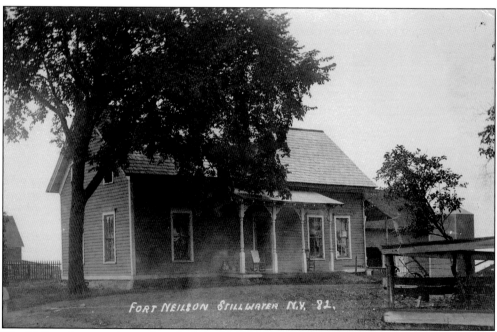

The Neilson farm was located on the battlefield and served as the residence of John Neilson, his wife Lydia, and their children. The ancestors of Neilson remained on the farm until 1923 when it was deeded to the Saratoga Battlefield Association.

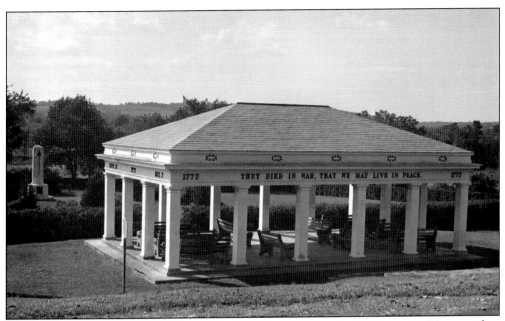

The Rest Pavilion, designed and constructed by New York State in 1927, was a 1,176-square-foot painted wood structure built on concrete in June 1929. It had gold-painted raised wooden lettering on the outside of the frieze reading "September 19th" and "October 7th" on the front, and on the east side facing the state road, "1777" on each end, and "They died in War that we may live in Peace." It was removed by the National Park Service in 1960.

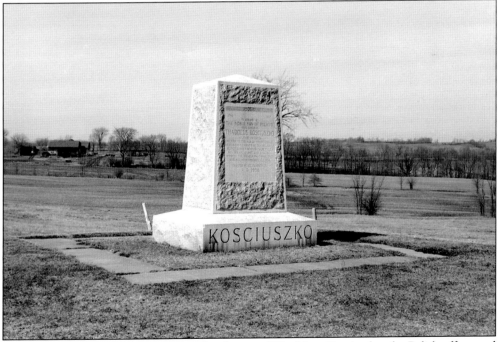

The Kosciuszko monument was erected in honor of Thaddeus Kosciuszko, the Polish officer and engineer who chose the site of Bemis Heights for the battle that led to the eventual surrender of Gen. John Burgoyne.

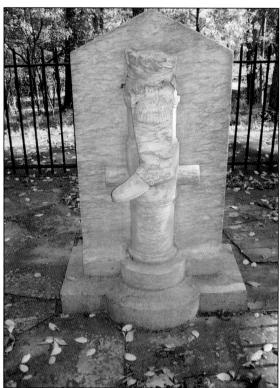

This monument shows the boot of Benedict Arnold, who was wounded during the second battle of Saratoga. No verbiage is marked even though he was considered a hero of the battle. It is located at stop seven on the battlefield.

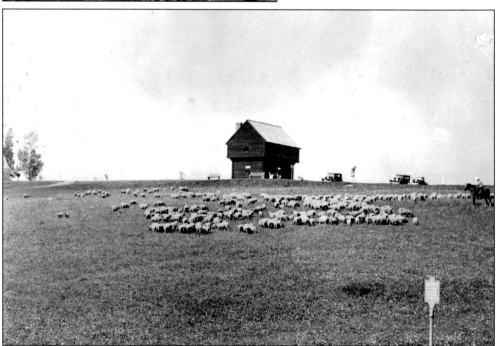

The battlefield had many farms on it and was used as such. This picture was taken sometime after 1927, as the blockhouse is seen in the distance. The Neilson family lived on the battlefield until 1929.

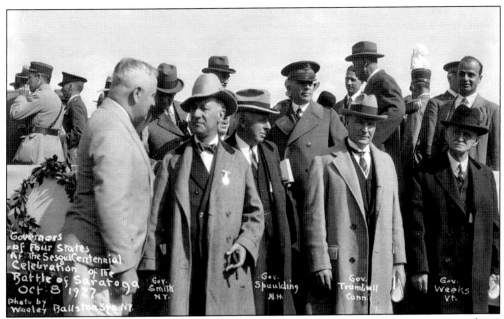

The sesquicentennial event brought four governors of the states where the patriots came from. From left to right are unidentified, Gov. Alfred E. Smith of New York, Gov. Huntley Spaulding of New Hampshire, Gov. John Trumbull of Connecticut, and Gov. John Weeks of Vermont. It is unknown who is standing behind them.

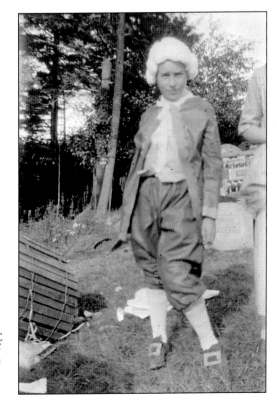

This is a picture of the youngster that was involved with the sesquicentennial pageant. His name is David Hayner, the eldest son of Earl and Susan Hayner. Susan served as the town of Stillwater's historian for over 40 years.

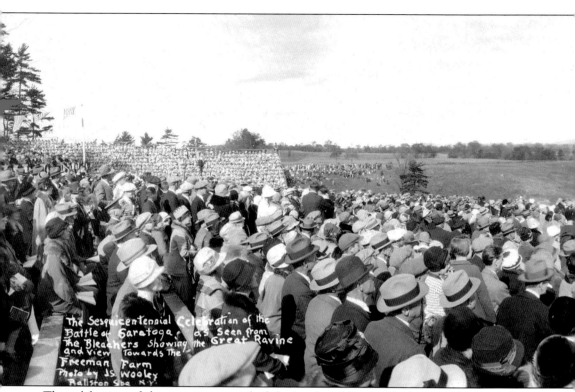

The celebration of the sesquicentennial of the battles of Bemis Heights and Freeman's Farm took place on October 7, 1927. A pageant was performed with almost everyone in the area

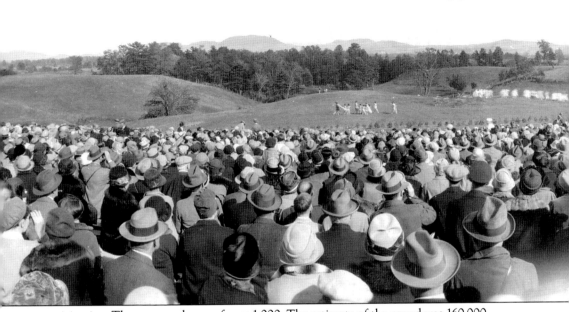

participating. There was a chorus of over 1,000. The estimate of the crowd was 160,000.

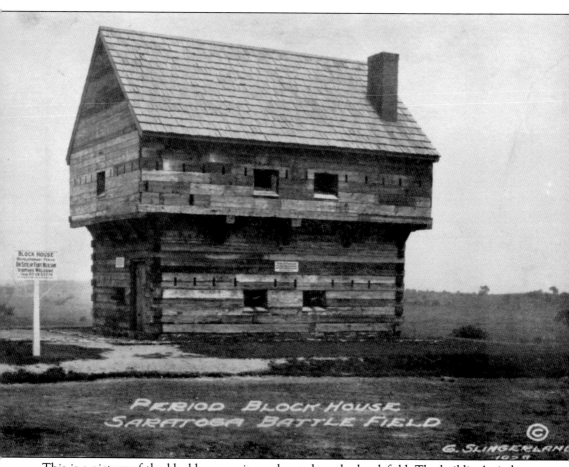

This is a picture of the blockhouse as it was located on the battlefield. The building's timbers came from many of the family farms, including the Neilsons, the Gannons, and the Smodells. It was called Fort Neilson, as it was near that family's farm. Jane and Elizabeth Neilson used to act as guides.

The first time residents of Stillwater saw Pete, the wild goose, was a bleak day in December when he floated around a bend in the river, comfortably ensconced on a cake of ice. His white plumage stood out vividly against the background of the darker waters, and as the villagers watched, they saw him slide off his perch and start the long swim toward shore. A few minutes later, Pete was waddling up the main street, surveying the populace with a cautious scrutiny.

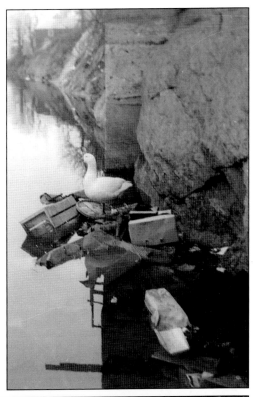

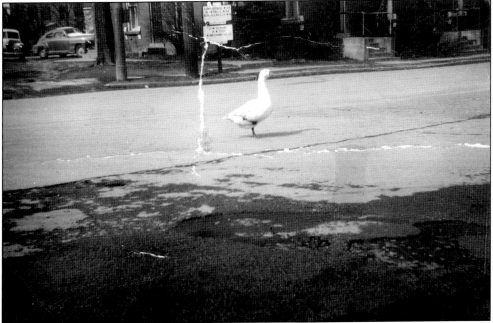

Those who saw Pete daily never ceased to wonder if he planned to stay or one day fly off to his native haunts in the northland. His habit of waddling out into the main street and ignoring the horns of irate motorists led some to believe he may meet his end under the wheels of a car. He was given a new home at the Canary Farm and lived happily ever after.

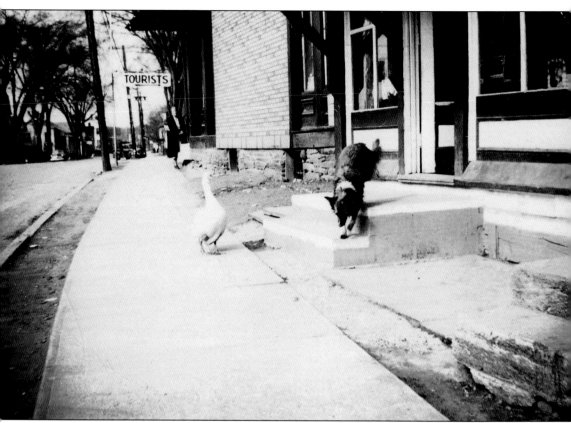

Those who know Pete best have good reason to believe he has remained in Stillwater strictly out of fondness for Brownie, a long-haired dog owned by Thomas and Virginia Mehan. In every respect, save his carryings on with Brownie, life in Stillwater has become routine with Pete. During his first few days in the village, he was wary of passersby who ventured too close. But now he permits his select friends to pick him up, feed him by hand, and even run their fingers through the thick feathers on his back. He takes everything in stride it seems, except Brownie, and when the shaggy dog emerges from the front door of its master's house. Pete snaps to attention and starts off at a brisk waddle in pursuit of his one and only. The dog takes a dim view of Pete and generally gives the goose an artistic brush-off and trots away in search of company more to its liking. This photograph shows Pete and Brownie on the steps of Smodell's Store.

Two

CHURCHES

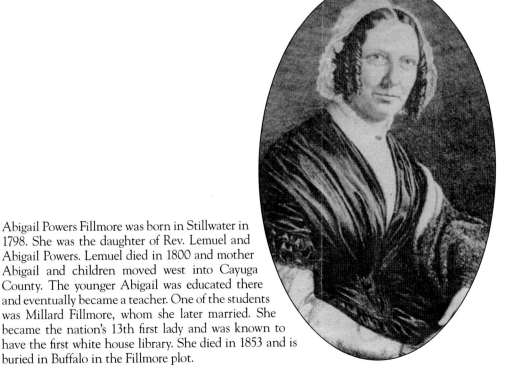

Abigail Powers Fillmore was born in Stillwater in 1798. She was the daughter of Rev. Lemuel and Abigail Powers. Lemuel died in 1800 and mother Abigail and children moved west into Cayuga County. The younger Abigail was educated there and eventually became a teacher. One of the students was Millard Fillmore, whom she later married. She became the nation's 13th first lady and was known to have the first white house library. She died in 1853 and is buried in Buffalo in the Fillmore plot.

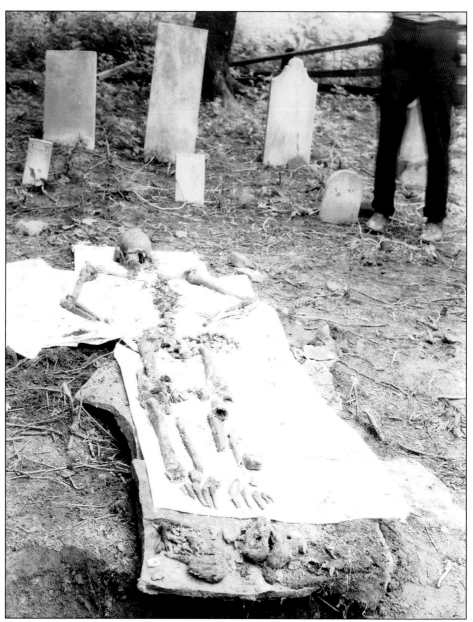

Rev. Lemuel Powers came from Vermont and settled in Stillwater. He was one of the founders of the First Baptist Church, and he also founded several others in this area. He died suddenly and was buried in the Manger Cemetery. He was exhumed in 1937, and his body was placed in a spot near his church on Route 423. This picture was taken at the time of his reburial. This is a description by Susan Hayner, as she was a witness to the exhumation: "I tried to construct a picture of the man in life from the bones lying spread out. A tall man truly and powerfully built. His humerus, the only bone I could measure in its length was 14 1/2 inches, longer than any ones about. His head across from side to side was 6 inches, from back to front 7 3/4. His jaw from chin to bend under the ear was 3 1/2. His teeth met evenly, firmly and perfect. Forehead sloped backward and low. The skull otherwise was well shaped and rounded out in the back. Some dark hair was visible on the side."

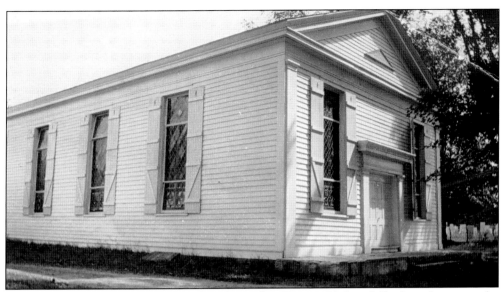

This is the First Baptist Church building, located on Route 423. It is difficult to determine the exact date it was built, as it was possibly part of the original church that may have been moved to this site. The last service was held in the 1940s. The building remained empty for many years, was later sold, and then demolished.

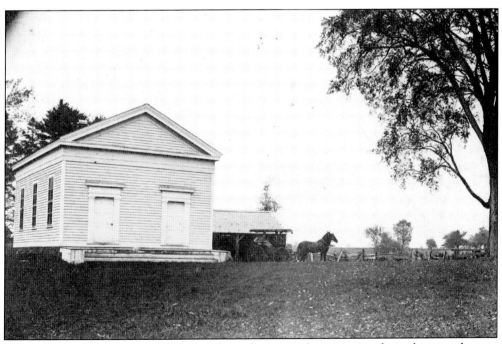

This was the Yellow Meeting House, and members were Congregationalists who came here in 1762 from near Canaan, Connecticut. The minister was Rev. Robert Campbell who served them until death in 1789. The building was painted yellow, hence its name. This church remained active until 1930s. The building was later sold and demolished. The cemetery remains, and several of the founders are buried there.

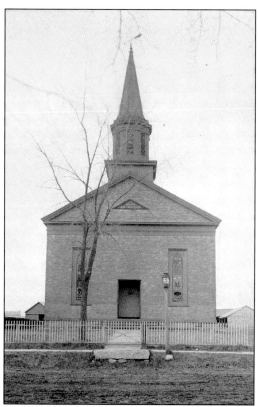

This First Presbyterian Church in the village was called the Session House and was built around 1841. It was used until 1891. The Presbyterians were offered a new church building by Mallery Schoonmaker. It was an offer they could not refuse. After they moved to the new church, the old building was used as the offices of the Hudson Valley Railway Company.

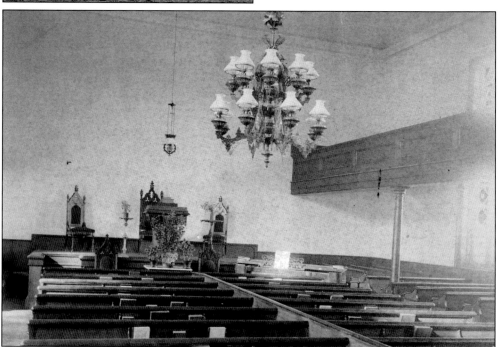

Here is the interior of the Session House. The sanctuary had a balcony, and the lighting was originally by candle. Gaslights were later used. The pews were for the parishioners' use.

The First Methodist Church was located on Hudson Avenue. It was built in the 1800s and was used until 1947 when the congregation merged with the Second Baptist Church and the Schoonmaker Presbyterian Church. It was sold to the Masonic temple's Montgomery Lodge No. 504 in 1953 and remained until the disbandment of the lodge in 2005. The temple was sold to John and Susan Basile and is now a private residence.

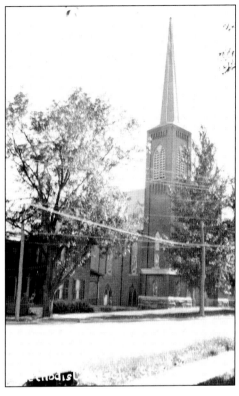

This is a picture of Isadora Palmer, who was known as the mother of the Gradium Club of the First Methodist Church. This club was a group of ladies who first met in 1907 on Sundays beside the big heater. Palmer was noted for her patience and loyalty. This group raised funds for many projects in the church. Palmer was also a noted artist, using watercolors. Her pictures are still in several homes.

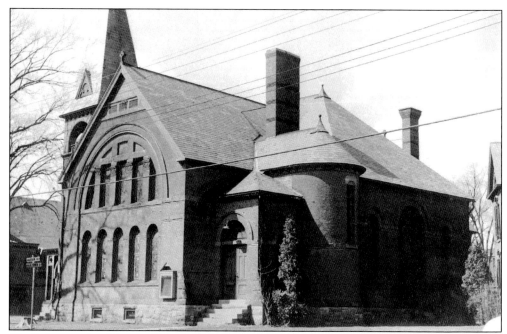

The Schoonmaker Memorial Presbyterian Church was located on the corner of Hudson Avenue and School Street. Mallery Schoonmaker donated the building in memory of his parents. The church was noted for its beautiful stained-glass windows. The manse next door was used by the ministers until 1994. The church burned in 1948 and was later demolished.

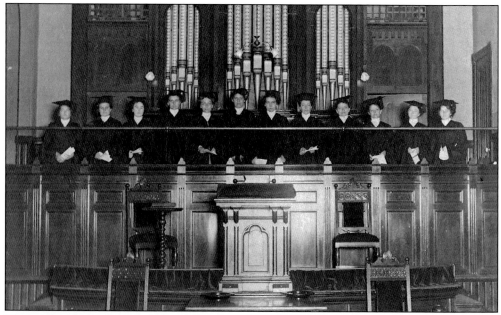

This picture was taken in 1911 of the choir from the Schoonmaker Memorial Presbyterian Church. The choir loft was located above the pulpit area. Note the hats that were worn by the members. Pictured from left to right are Marjorie Hudson, Josephine Bloomingdale, Bertha Knibbs, Maude VanWie, Kate Lottridge, Louise VanDeMark (organist), Virginia VanWie, Lillian Becker, Lena Hewitt, Mrs. DeLong, Lillian Becker, and Rosella Livingston.

The Second Baptist Church was built in 1873 and has been continually used, as it is now the United Church Presbyterian. This congregation was founded in 1836, as many were previously members of the First Baptist Church who felt the need to have their own church in the village.

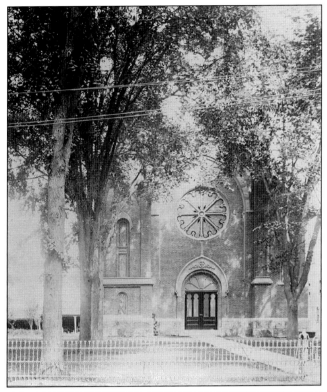

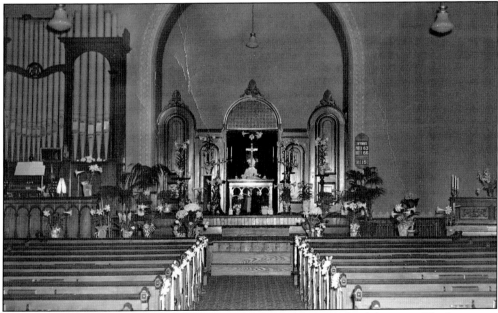

The interior of the Baptist church is shown as it looked prior to the federation. The baptistery is behind the chancel area and was not removed when the sanctuary was renovated. The walls were dark in color along the wainscoting. The choir loft was on the south side of the sanctuary. The federation took place in 1947 and in 1952, a vote was taken to affiliate with the Presbyterian denomination.

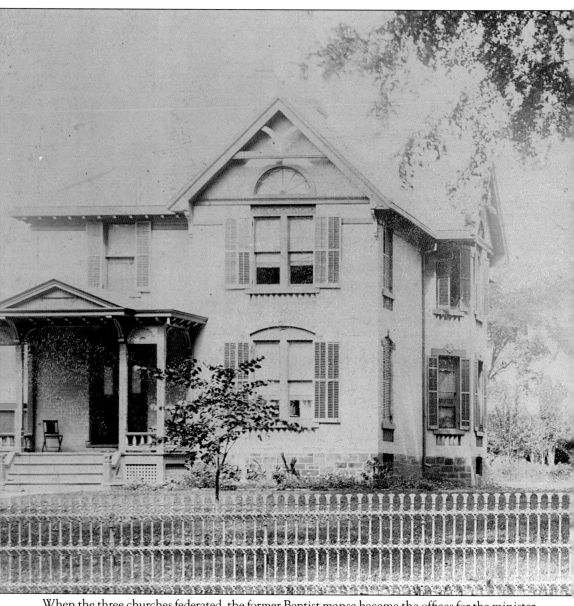

When the three churches federated, the former Baptist manse became the offices for the minister and church workers and a meeting area. The second floor was used as an apartment for the church workers. Ruth Whittle was the first director of Christian education and Marilla Webster served as the second.

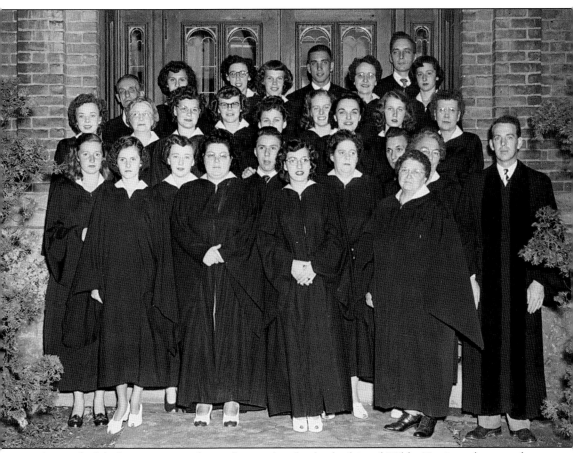

A wonderful choir was joined together under the leadership of Hilda Hewitt, who was the Baptist organist, and Helen Doughty, who was the Presbyterian choir director. From left to right are (first row) Percilla Aldrich, Dorothy Stevens, Nancy Doughty, Barbara Alexik, Ronald Pickett, Louise Pickett, Irene Brownell, Herbert Pickett, Bessie Vandenburgh, Alida Hayner, and Rev. Robert Thomas; (second row) Eleanore Doughty, Cordelia Pitney, Jerry McChesney, Joan McChesney, Lois Hill, Nancy Whittle, Mildred Hayner, Clara Ann Gilgallon, and Hilda Hewitt; (third row) Fred Hayner, Marilyn Cowin, Jessie Truland, Alice White, Warren Truland, Helen Doughty, Robert Hayner, and Joan Travis.

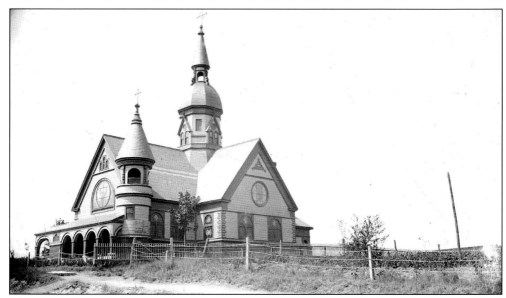

The St. Peter the Apostle Church came into existence in 1889. Prior to that, Catholics traveled to Mechanicville to worship. The cornerstone was laid by Bishop Francis McNeirney on July 21, 1889, and in 1892, he returned for the dedication. Fr. John Flynn became its first pastor.

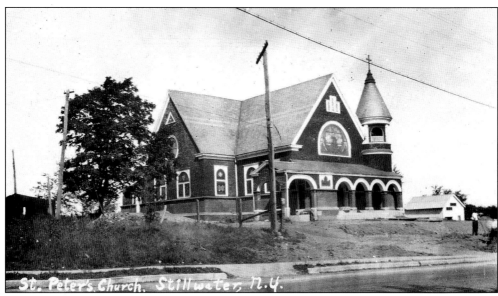

The extensive repair to the exterior of St. Peter's church was completed in 1920. On July 21, 1921, St. Peter's became an independent parish and began its actual work at this time. The look of the church has not changed and appears the same today.

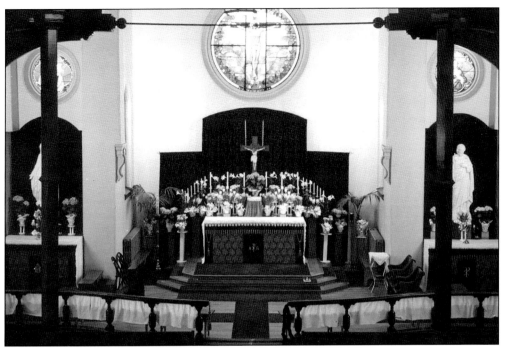

Here is the interior of St. Peter's church. This photograph was taken prior to the change in doctrine. Note that the altar is not facing the congregation. This change took place in 1960. The pastor at the time was Fr. Charles Gaffigan.

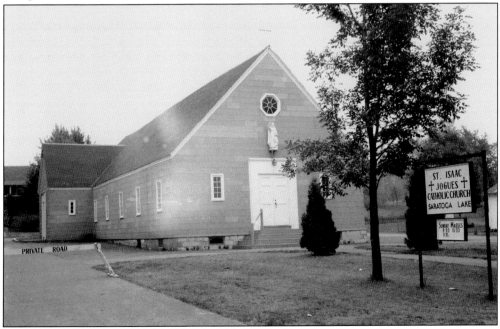

Land was purchased in 1943 on the east side of Saratoga Lake. A chapel was erected under the leadership of Fr. Lawrence Kelly. The name for the chapel was chosen to honor St. Isaac Joques, the martyred priest who traveled in this area in 1646. The chapel is open from Memorial Day weekend to Labor Day.

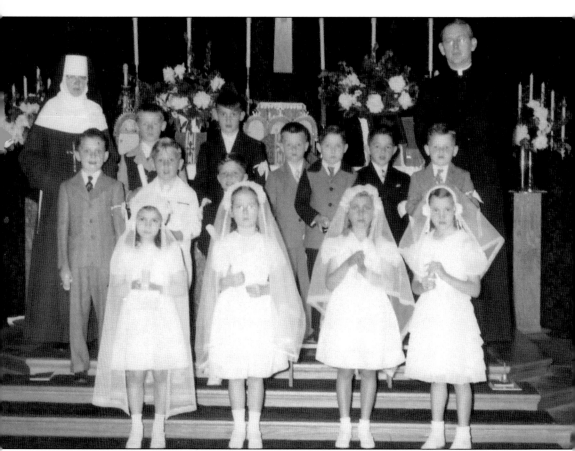

A first communion class is pictured here in 1948. From left to right, the children are (first row) Nancy Comerato, Marie Canary, Mary Ann Gemmiti, and unidentified; (second row) Gerald Oswald, Donald Price, Peter Birdsinger, James Overocker, Edward McClements, and Bruce Barbolt; (third row) unidentified, James Brooking, and Ryall Nolan. Fr. Lawrence Kelly is seen on the right.

St. John's Episcopal Church was built in 1873, and the cornerstone was laid in 1874. It is located on Hudson Avenue, and although it is no longer used as a church, its occupancy is insured as the Stillwater Free Library. The stained-glass windows came from England.

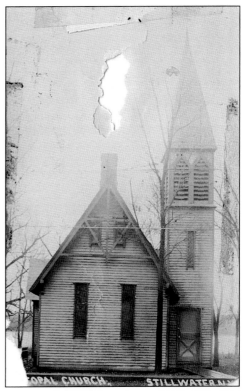

In the hamlet of Ketchums Corners was a Methodist church that was firmly established by 1832. The mother of Bertha Caldwell gave the following description of the interior: "The plain bare room, with a very high pulpit and surrounded on three sides by a gallery, was barren of comforts. Straight back cushion less seats, a bare floor, such inadequate heat that foot warmers were the order of the day. Fluted candle sticks and tallow candles hung around the sides of the room for light."

The chapel in Willow Glen was under the direction of the First Methodist Church of Mechanicville. On Sundays, Deaconess Hattie Gifford went there to have a service for those in that area. The building is still there but has been abandoned for many years.

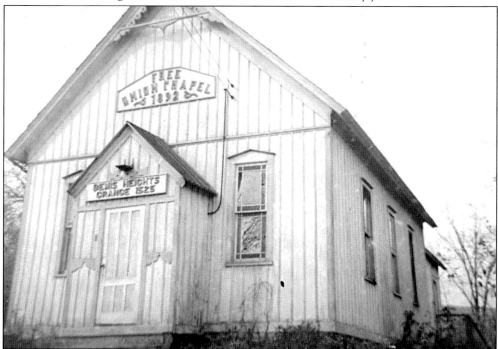

The Union Free Chapel on the edge of the battlefield at Bemis Heights was built in 1892. The old wooden structure beside the brook was shaded by a huge elm tree under which circuit preachers paused to hold services for the battlefield farmers. The chapel was nondenominational and was also used as the home of the Bemis Heights Grange. It was later razed.

Three

BUSINESSES

This is an advertisement about the White Sulfur Springs. Folklore has it that the White Sulfur Springs provided shelter for the Devil on one occasion. The story goes that a hardworking man named George Jones made a pact with the Devil to eliminate his constantly nagging wife, Eleanor (Nelly) Jones. The husband was said to have given himself to the Devil for a term of 10 years. As legend has it, that spunky, nagging wife grabbed a pair of tongs and beat a tune on the Devil. Seemingly getting the better of the physical encounter, she seized his long tail and administered agonizing pain. The Devil then fled on horseback to the southern extremity of the lake, where he stopped suddenly. The earth beneath him opened with a noise, and his horse disappeared in a chasm. Where the Devil entered the earth, a sulfur spring broke forth, known to this day as White Sulfur Springs.

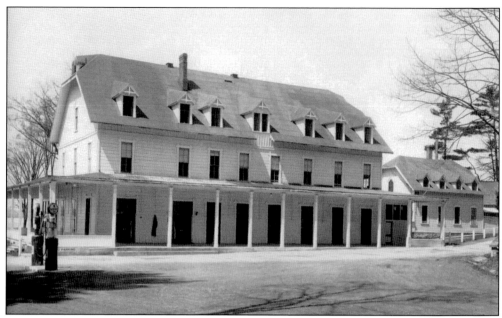

White Sulfur Springs Hotel was very well known and had many famous visitors. During the racing season at Saratoga, the hotel was filled with the likes of Lillian Russell and her constant companion, Diamond Jim Brady. Another draw to the hotel was its wonderful food. The Luther family owned the hotel from 1883 until it was sold in 1946. The hotel was razed in 1957 to straighten Route 9P around the lake.

This picture shows Shorewood, the home of Thomas C. Luther and his family. Over the years, he was led into forest conservation, and at the time of his death, he was owner of one of the largest forest plantations in the country. This was carried on by his son Thomas F. Luther.

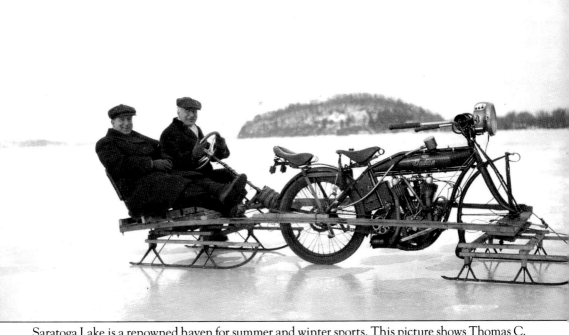

Saratoga Lake is a renowned haven for summer and winter sports. This picture shows Thomas C. Luther (right) on an ice bicycle with runners. Ice was also cut from the lake and stored in the icehouse so it could be available year around. It is not known who is with him.

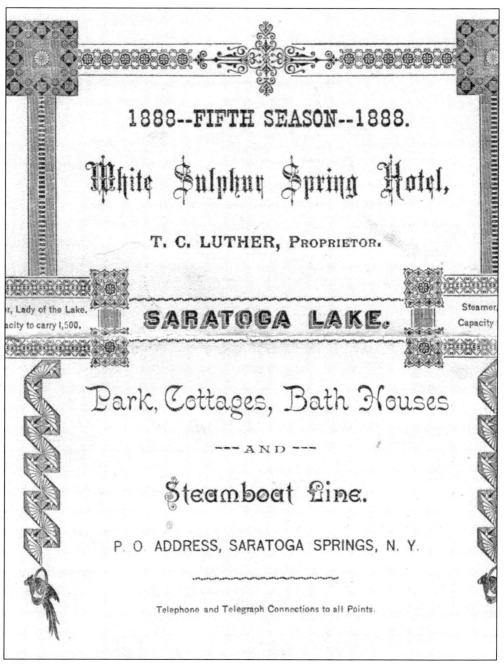

1888--FIFTH SEASON--1888.

White Sulphur Spring Hotel,

T. C. LUTHER, PROPRIETOR.

r, Lady of the Lake.
acity to carry 1,500,

SARATOGA LAKE.

Steamer,
Capacity

Park, Cottages, Bath Houses

--- AND ---

Steamboat Line.

P. O. ADDRESS, SARATOGA SPRINGS, N. Y.

Telephone and Telegraph Connections to all Points.

This poster was one of many that advertised the steamboat *Alice*. August was the month that the Saratoga Racetrack was open, and with the hotel full of guests, a little excitement was always available. There were electric trolley cars that took passengers from the boat to areas in Saratoga Springs.

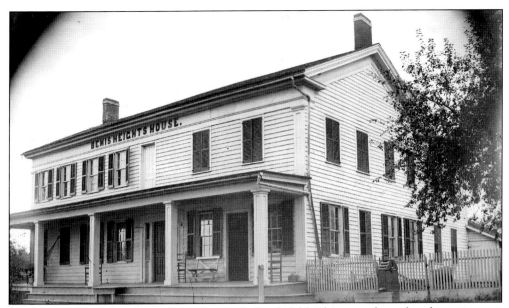

The Bemis Heights Hotel was located near the battlefield. This was a large, handsome inn run by the Mather family in 1927. Dorothy Alsdorf, a former Saratoga Country historian, was a teacher in the country school who boarded there. It was later razed in the 1950s.

The Stage Coach Inn was located in the hamlet of Willow Glen. It was located on the road to Ballston. A stagecoach was a means of transportation during the 18th century and was also a way of taking mail from one town to another. The building remained an inn for a number of years and then became the private home of the Wood family.

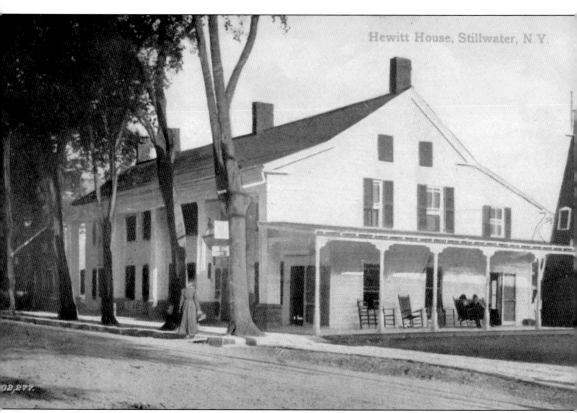

The Hewitt House was originally the Andrew Hunter Hotel in 1846. In the 1890s, at the height of Stillwater's prosperity, it was owned by Harvey Hewitt. The hotel was noted for its fine foods and the trolleys stopped right at the door. A windmill on the south side brought river water into the hotel, which enabled it to advertise that there were bathrooms with hot and cold running water.

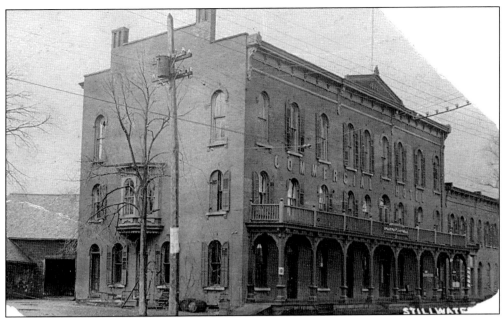

The Commercial Hotel was built in 1875 and was marked as a depot station for the Hudson Valley Trolley Line. In 1895 and 1896, it was called Pitney House after its owner, William Pitney. Many activities were held there, from band concerts to a political caucus. Around 1904, it was purchased by Thomas Joyce. The name was changed to the Moose Head Inn when a 1,600-pound Maine moose was donated. The building was demolished in 1982.

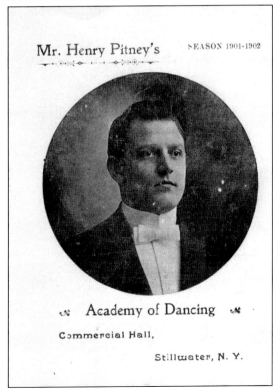

Henry Pitney, son of William Pitney, was noted for his musical ability. He ran the Academy of Dance at the Pitney house. Private lessons were available, and all the latest dances were taught. The cost for these lessons was 25¢. He was also involved with the Pemble Band.

Aldrich's Service Station is located on North Hudson Avenue. It was originally a chicken coop. Percy Aldrich and Richard Osgood were partners for approximately a year. In 1929, Aldrich started a business by himself. It was a garage that did car repairs and sold gasoline. It also sold penny candy, bread, and cigarettes and was considered a variety store. The gasoline station was a gathering place for many card games. When he retired around 1960, the business was passed on to his son Milton who still runs it. From left to right are Milton Aldrich, Aileen Aldrich, Percy Aldrich, Donald Goodrich, Lynn Goodrich, and Walter Cowin.

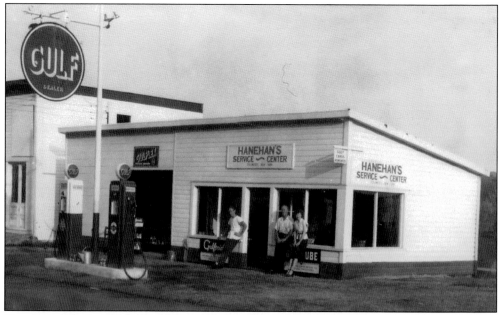

Hanehan's Garage was located by the Hudson River Bridge and was run by Walter Hanehan (center). He was noted for working on all kinds of automobiles. Like many businesses, it was a family affair. The Hanehan children worked in the store part time. Pete the goose made the store one of his homes. The garage was later sold to Brayton Jones and was razed after a fire. Walter's daughter, Marie, is also seen in the photograph.

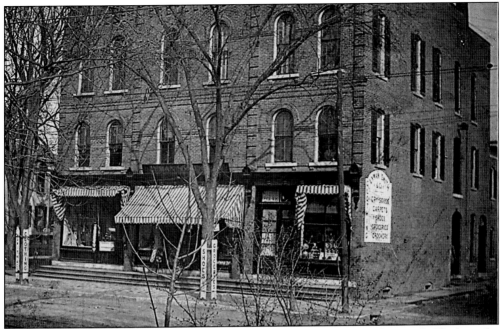

Lyman Smith's department store was located on what was known as the Smith Block at the corner of Main and School Streets. The store's advertisements told how to avoid paying high prices, as there was a grantee with each item. The store was originally begun by Smith's father in the late 1800s.

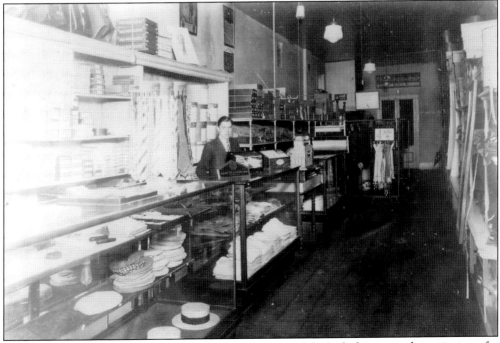

This picture shows the interior of the department store. Men's clothing was the main item for sale. Note the straw hats in the glass counters. The people in the store are Smith and his clerk, Hazel Osgood.

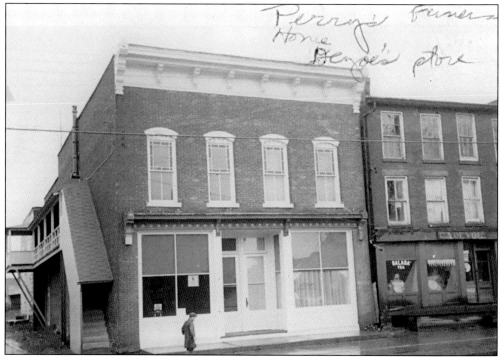

Here is the funeral parlor on Hudson Avenue. The original owner was William R. Palmer. The business was later sold to Aubrey Perry who used the left side as a furniture store and the other side was the undertaker parlor. The second floor is an apartment that the Perrys lived in. The building still exists and is known as Dunn's Funeral Home, owned by Robert Chase.

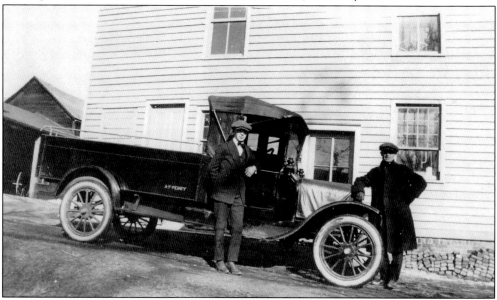

Prior to the purchase of a hearse, this truck is what was used to carry furniture for delivery and even caskets. This picture was taken in the 1920s. Perry sold his business to J. Dwight Dunn in late 1950s. Perry was a short man with white hair and smile that made people feel secure with him.

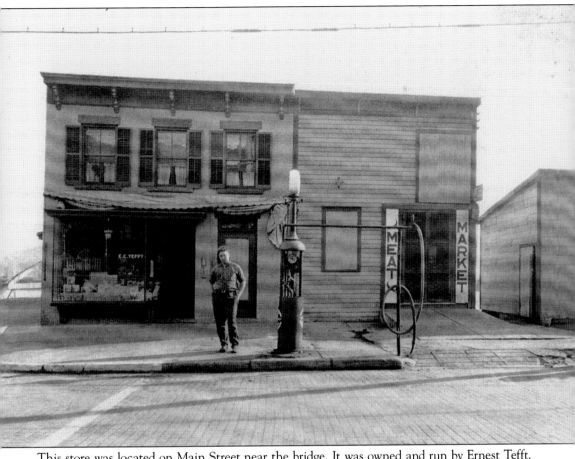

This store was located on Main Street near the bridge. It was owned and run by Ernest Tefft. This was where the original bridge and tender's office was located in the village. Note the gasoline pump in front. The young man standing there is Eugene Smith, who worked for Tefft after school.

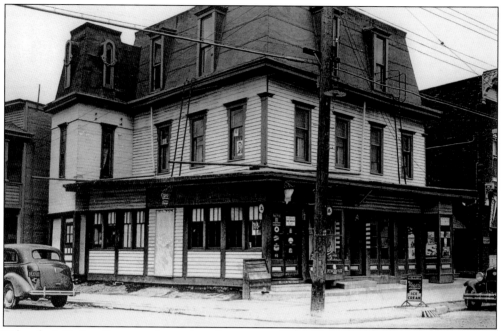

Talmadge's Variety Store was located on the corner of Hudson Avenue and Lake Street. Noted for its wonderful choices of penny candy, one could take quite a while to make a decision. Margaret and Harold Talmadge were the owners. Apartments were above the store. The building was owned by Lewis Smodell.

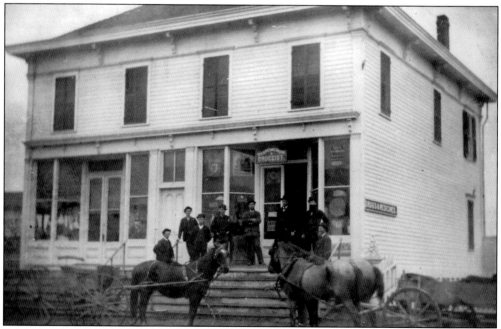

Schermerhorns Drug and Apothecary was located on Hudson Avenue. The druggist was William Schermerhorn, and he was always be available for the residents. There was also a Chinese laundry in the same building. This business lasted a very short time. After the drugstore went out of business, the building was later converted into four apartments.

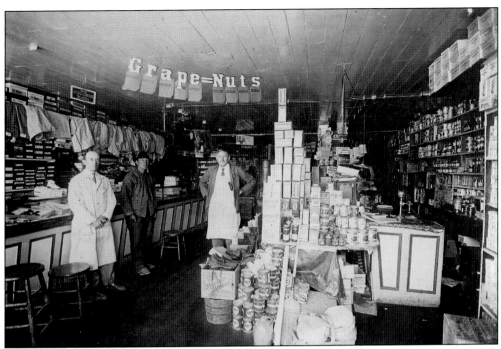

Deyoe's grocery store was located on Hudson Avenue and was owned by Webster Deyoe. As with many of the other markets in the village, Deyoe's was noted for its fine meats. An active member of the community, he served on the school board for many years.

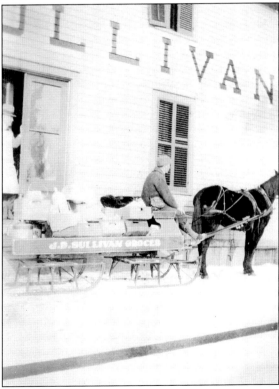

Sullivan's store and saloon was built about 1880 by Jerome Sullivan. It was located on the bustling Champlain Canal. A good saloon business was done by the canallers, and there was much imbibing of the spirits. After Sullivan's death, his nephew Jerome Sullivan II carried on the grocery business but discontinued the saloon. The store was later converted into apartments. This building was destroyed by fire in 1985.

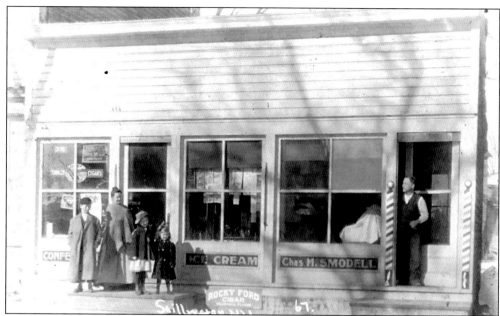

Smodell's Confectionary and Bakery Shop was located next to the Moosehead Inn on Hudson Avenue. The original owner was Charles Smodell, who was a barber. There were a couple of tables and chairs for customers to enjoy there refreshments. The store remained in the family until 1970. Pictured from left to right are Jay, wife Leisetta, daughter Leisetta, Charlotte, and Charles Smodell.

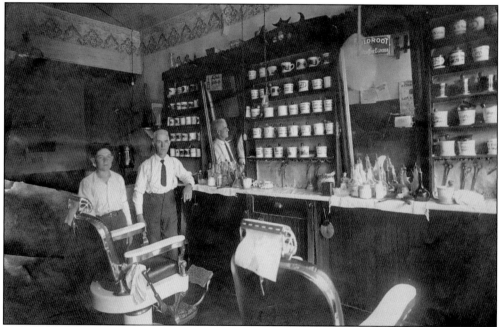

Lewis Smodell, the brother of Charles, was also a barber. His shop was located on the corner of Hudson Avenue and Lake Street. He was the owner of that block. There was an apartment on the second floor that was usually rented. Note the shaving mugs on the wall, showing that this was a popular barbershop. Lewis (left) is pictured with an unidentified person.

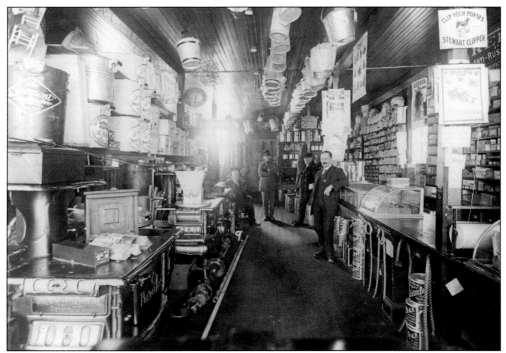

Durham's Market was owned by Fred Durham. It was located on Hudson Avenue, and the advertisement said, "If the ham or sausage that you had for your first meat or the roast you had for dinner did not please you it was because you didn't buy it of Fred B. Durham, Central Market." The picture shows Fred Durham (right) with three unidentified people.

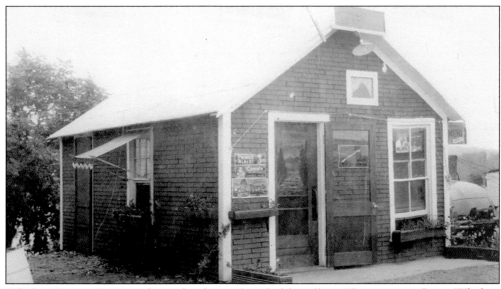

Whalen's Variety Store was located at the south end of the village. The owner was James Whalen, who was a friend to all. The store sold groceries and gasoline. It was a gathering place for those who lived in that area. After Whalen's death, his sister Catherine Lane and his son Cyril ran the store until its closing in the spring of 1967.

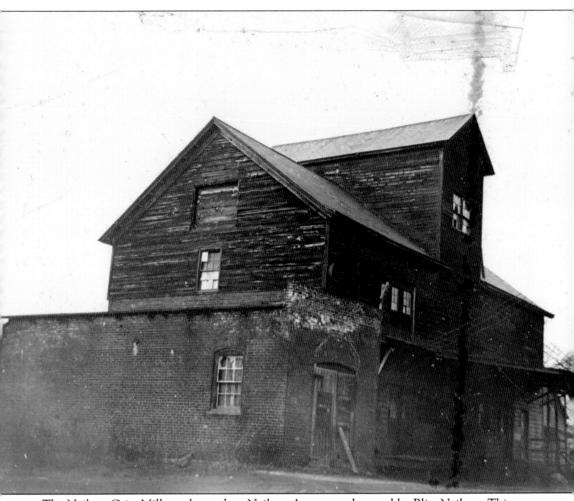

The Neilson Grist Mill was located on Neilson Avenue and owned by Bliss Neilson. This was a very old mill, probably built in the 1850s. The Furlongs purchased it in the 1920s. In an interview with Mary Furlong, she recalled the 16-inch hand hewn beams that were put together with wooden pegs.

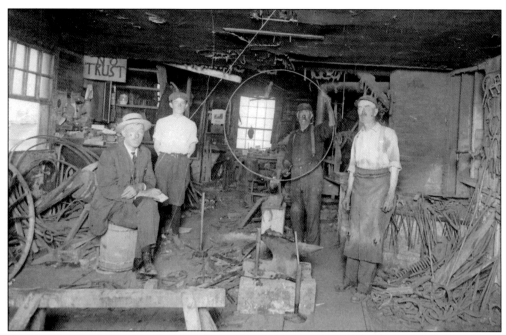

Patrick Flynn's blacksmith shop was located near the bridge going across the Hudson River around 1918. The wheels shown in the picture were made by Albert Smith from Bemis Heights. He waited for a journeyman blacksmith to come through Stillwater to scrunch the rims onto the wheels. It took a couple of young boys to drop water onto the tires at the right time. Note the sign that says "No Trust."

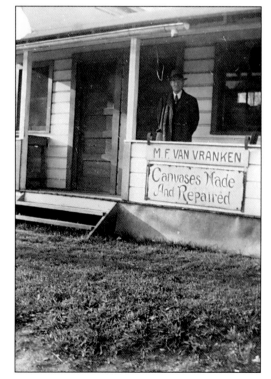

The VanVranken Canvas Shop was owned by Michael Freligh VanVranken. This building was originally a double cabin and was located in Bemis Heights. It was moved by placing telephone poles underneath and rolling it to the village. He repaired canvas in this building until his retirement. This building later became the first library.

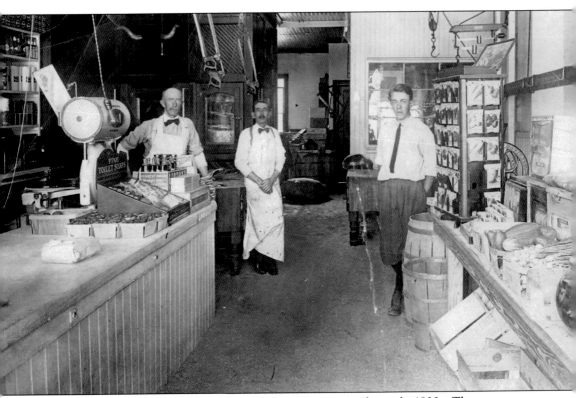

Hunters Hardware was also located on Hudson Avenue in the early 1900s. The owner was Edward Hunter. The store had many items for the household, including coal. Like most stores, this was also a gathering place to catch up with the news from the village.

Four

THE INDUSTRIAL ERA

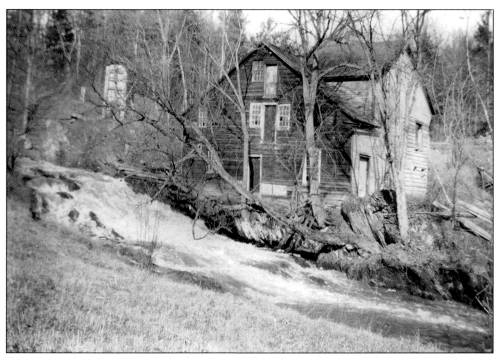

Few area residents are aware that a thriving mill flourished within a stone's throw of the Saratoga National Historical Park. This thriving sawmill, gristmill, and plaster mill was operated by Daniel Smith, whose history dates back to the time of the Revolution. Although the mill was destroyed in 1910, remnants, including the millstone, were found in the 1970s.

The Pemble Mill was located on Hudson Avenue and manufactured straw board, which is a coarse cardboard made of straw. The Pemble brothers, Daniel and William, established this business in 1866, and about 12 hands were employed. They averaged between 12 and 15 tons of board a week in 1873.

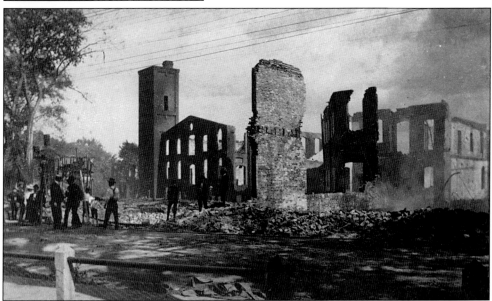

It was a Sunday afternoon on June 26, 1904, at approximately 3:00 p.m. that the church bells rang along with the gong at the firehouse. The fire started in the Newland Mill of the Saratoga Knitting Mills, and within 10 minutes, the building was a mass of flames. The mills had just finished extensive changes, including a sprinkler system, but they were not turned on. The locations today are part of the Blockhouse Park. The picture shows Main Street and Lake Street.

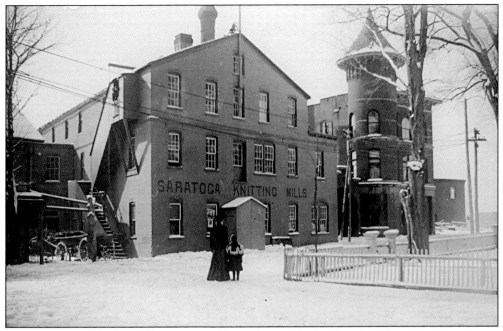

The Saratoga Knitting Mills was owned by Ephraim Newland and William Denison. It was established in 1873 and at that time employed an average of 50 hands. It manufactured gentlemen's and ladies underwear, averaging about 75 dozen a day. At the time of the fire in 1904, the mill employed over 150 people who ended up unemployed.

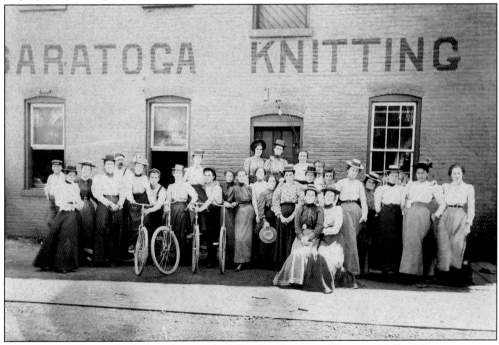

This picture shows the ladies that worked for the Saratoga Knitting Mills. There were two separate mills: one was the Newland Mill, and the other was the Denison Mill. The average wage in 1904 was $12.50 per week.

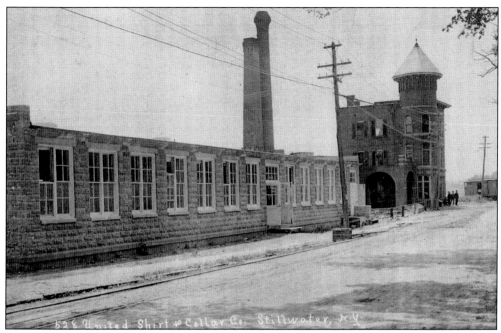

The United Shirt and Collar Company was located north of the Saratoga Knitting Mills. The disposable collar made famous in neighboring Troy was made there, too. The average number of employees was near 50. It closed in the 1930s.

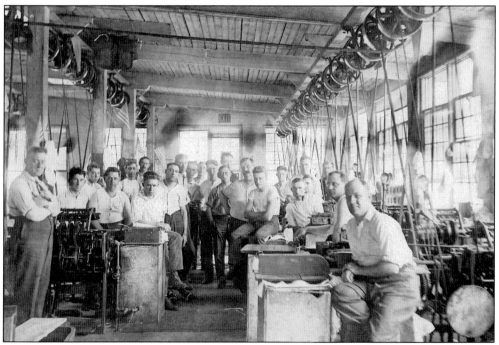

The employees were mainly local residents who usually worked five to six days a week. Piece work was usually the norm with a certain amount that had to be completed. The gentleman on the left is Frank Moore, who was the supervisor.

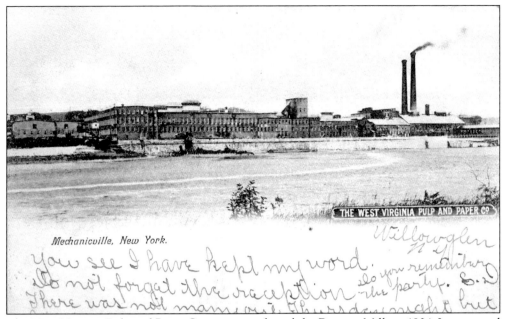

Mechanicville, New York.

You see I have kept my word.
Do not forget the reception — the party. S. D.
There was not many out Thursday night but

The West Virginia Pulp and Paper Company purchased the Duncan Mills in 1904. It was noted for making high-quality paper, especially for books. Sulfite fiber was used in the paper-making process. Many can remember passing the mill and smelling the noxious fumes. The company closed the mill in June 1971.

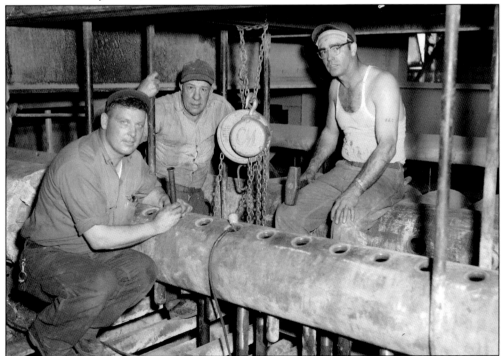

This photograph was taken in the Botler House at the paper mill. The men were putting tubes in the boiler. They had to be certified welders to perform this job. From left to right are Arthur Baker, John Clheck, and Ross Clothier.

The first electric cars of the Stillwater and Mechanicville Street Railway began running on December 2, 1896. This was one of the earliest railways. The powerhouse produced about 800 horsepower in about 575 to 600 volts. The power generated at the powerhouse was direct current and used extensively for the trolley cars.

Five

SCHOOLS

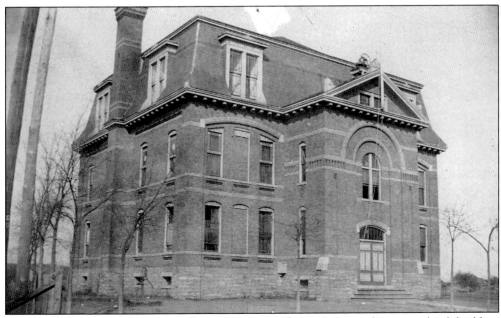

The Union School was erected in 1883 at the cost of $12,000. It was three-story brick building heated with steam. It had six schoolrooms, two recreation rooms, a library with approximately 500 books, and an auditorium on the third floor that held 500 people. In 1894, a compulsory attendance law was erected. Jacob Bradt was the first truant officer. At that time, students planted trees around the school.

In the beginning of the 1920s, the school became too small, and it was realized that a new school was needed. This school was built behind the Union School and was opened in 1927. When the playground area was built where that school was located, several of the bricks were found and now have a place in the historian's office.

Kindergarten was not compulsory until the early 1900s. Prior to that time, kindergarten classes were privately held. This 1902 photograph shows, from left to right, (first row) Helen Chase and Daisy Bradt; (second row) Dayton Case, Leisetta Smodell, Leone Bradley, and Gladys Hollenbeck; (third row) teacher Helen Davenport.

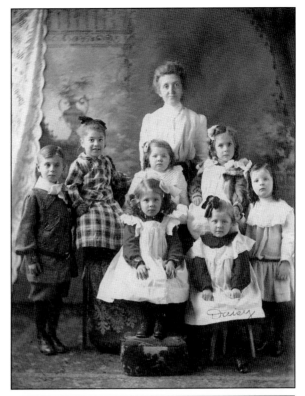

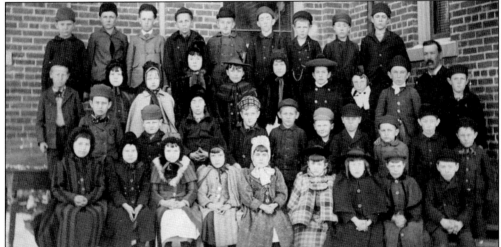

The teacher of this class in 1894 was Helen Davenport, and the principal was Willis Hinman. From left to right are (first row) Lillian Stewart, Nettie Hayner, Carrie Whitman, Edna Rose, Ethel Neilson, Nellie Smodell, Anne Haight, Isadora Quackenbush, and David Van Ness; (second row) William Bradley, Paul Irish, John Mahar, Leo Rancourt, Grover Wagner, John Fort, Edward Fort, Earl Hayner, Patsy Humphrey, and William Whales; (third row) William Green, Celia Hewitt, Addie Devoe, Katherine Mahoney, Anna Klinsing, Anna Oliver, Laura Bostwick, Myrtle Grosbeck, Charles Spicer, and Harry Greene; (fourth row) William Stewart, Jacob Pitney, Charles Seiter, Frank Carson, Louis Moll, James Humphrey, Merdith Carver, William Meehan, and Frank Luther.

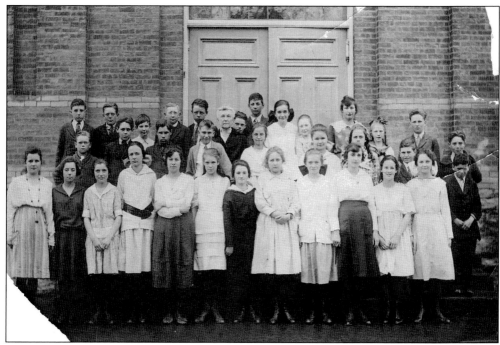

This picture was taken about 1917 on the front steps of the Union school. The teacher in the center is Ella Tucker. None of the student's names are listed. The Union School was known as school six in the district.

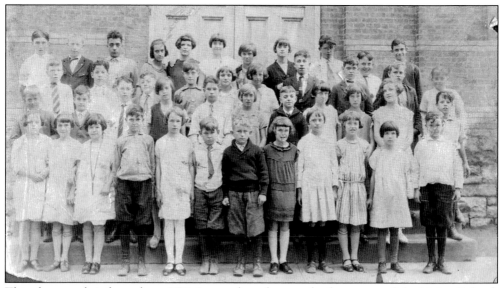

This photograph is from about 1924. It was also taken on the front steps of the Union School. Identified here are Mildred Campbell, Elizabeth Farrington, Catherine McNany, Henrietta Swan, Catherine Blizzard, Harold Campbell, Mae Moore, Dorothy Hill, Joseph Connelly, Lynn Goodrich, Russell Bull, ? Van Aernum, Beatrice Van Haggen, Kenneth Vandenburgh, ? Doty, Gordon Reniger, Helen Marchinski, ? Doty, Robert Hill, Larry Murphy, Michael Mohan, Ralph Flike, George Howland, Ralph Dinallo, Margaret Decoteau, Thelma Banks, Minnie Aldrich, ? Van Aernum, Thomas Hutton, and Gilbert Miles.

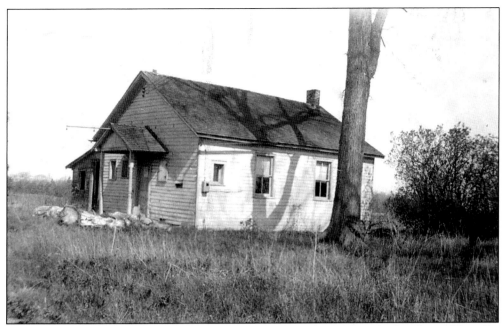

School district one was built in the early 1870s and was located in the hamlet of Wayville. This was always known as school one. The earliest records include a report from 1815. The centralization of the school in 1948 closed it, and the students were sent to the village. The building still exists but is abandoned.

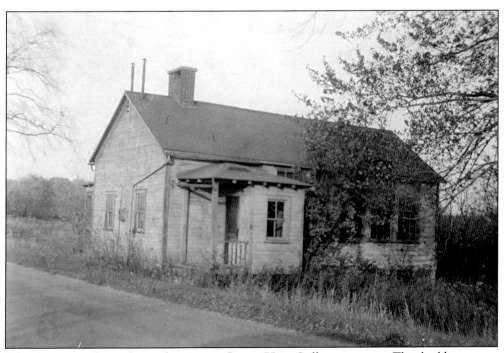

School two was located on what is now Route 75 in Stillwater center. This building was a one-room school that children from the general area attended. It was wooden and was later razed in the 1980s.

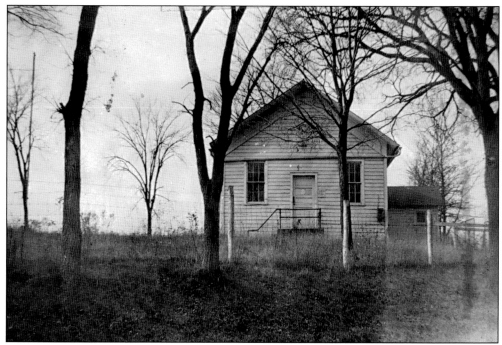

This building, school three, was located in the hamlet of Bemis Heights. Reports of the trustees in 1822 stated that it was in the town of Stillwater. It was built was in the late 1890s. The building is now a private residence.

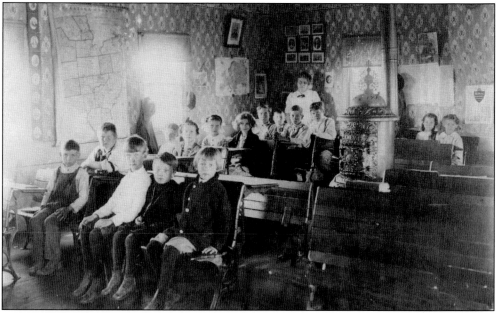

This picture from about 1910 shows the interior of the school. Seen here are Gilbert Ford, Frank Price, John Kristof, Joseph Kristof, Clifford Holmes, Guy Mathers, John Smodell, Mary Kristof, Bertha Smodell, Helen Smodell, Ruth Mathers, Edna McBride, Irene Post, Florence Gronczniak, Elizabeth Ford, Eleanor Price, ? Mathers (teacher), Mary Demyon, Louise Crandall, and Michael Kristof. (Courtesy of the Bertha Smodell Wolff collection.)

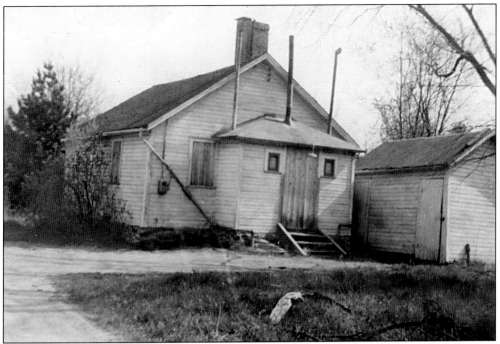

School four was located on Durham and Brightman Roads. This district was in the northwest part of town. Many of the students lived in the Saratoga Lake and Luther Woods area. This school building deteriorated and is no longer visible.

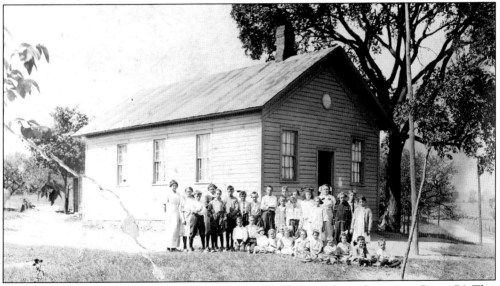

District five was known as the Round Top School. It was located on what is now Route 76. This picture is from about 1913. Seen here are Henry Marcella, John Marcella, Charlotte Barbolt, Zelda Robinson, Alice Post, Ethel Sisson, Harriet Sisson, Katherine Mehan, Raymond Mehan, Margaret Barbolt, Seth Handy, Leroy Britten, Steve Hilushe, Albert Flike, Roydan Robinson, Albert Barbolt, Alice Steele, Wilma Robinson, Ruth Handy, Clara Parry (teacher), Dorothy Baker, Margaret Robinson, Allen Sisson, Carl Hiluske, Waldo Robinson, Oliver Steele, Charlotte Post, Alice Blizzard, and Sterling Post.

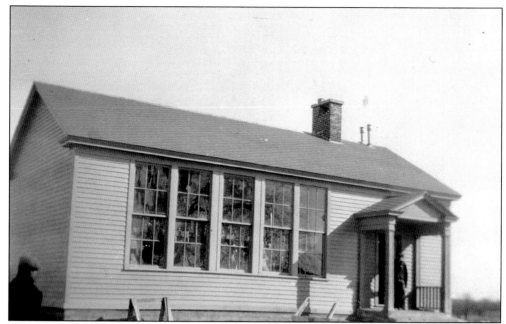

School seven was located in the Crow Hill district in the western part of Stillwater. This building was erected in 1928 after the previous one burned. This school also closed when Stillwater school centralized. This building was later a private residence.

District eight was in the Yellow Meeting House area on McDermott Road. This brick building was used until 1947. After being left vacant for several years, it was converted into an Arvin Hart fire station and used until 2001.

Ella Tice Tucker was born in Greenwich and graduated from Temple Grove Institute at Saratoga. She began teaching at the Stillwater Union School in 1878 and continued on until an illness caused her to retire in 1923. She gave her whole life to teaching school and was beloved by her pupils. She was a member of the Schoonmaker Memorial Presbyterian Church and the Christian Endeavor. She passed away on May 23, 1924, at the age of 74. The first Ella T. Tucker awards were given out in 1927. It is noticeable in her picture that she loved her pupils.

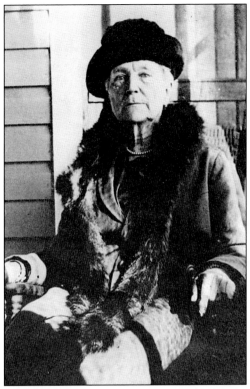

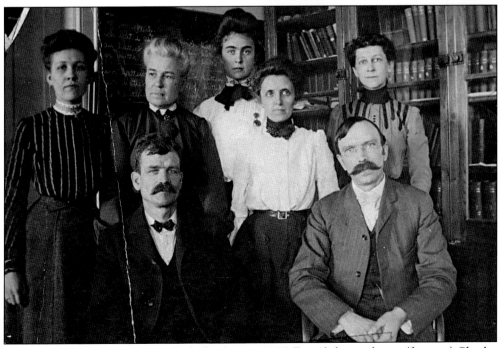

This was the entire teaching staff of school six in 1906. From left to right are (first row) Charles Haught and ? Gibson; (second row) Maude Rose, Ella Tucker, Helen Davenport, ? Roper, and Florence Congelon.

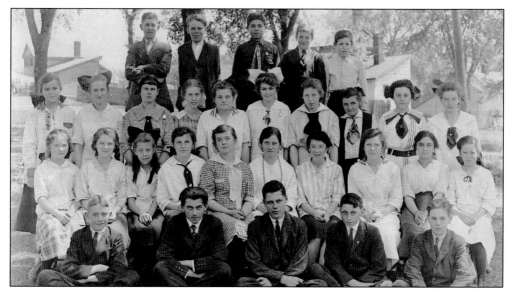

This is a picture of grades seven and eight from school six, also known as Union Free School, around 1918. Pictured from left to right are (first row) George Devitt, Albert Lawson, Harold McDermott, Harvey VanVranken, and Lester Osgood; (second row) Charlotte Smith, Gertrude Maloney, Edna Osgood, Gertrude VanVranken, Anna Martin, Alta Bradt, Janet Bradley, Gertrude Drumm, Edna Martin, and Elizabeth Manning; (third row) Emma Hall, Ida Spencer, Irma Robinson, Alice L. Lawrence, Irene Osgood, Helen M. Sullivan, Blanche Conlee, Anna Kirkpatrick, Addie Anthony, and Louise Highland; (third row) Stewart Brownell, Clarence Gailor, Albert Clements, Horton Pemble, and Robert Crawford.

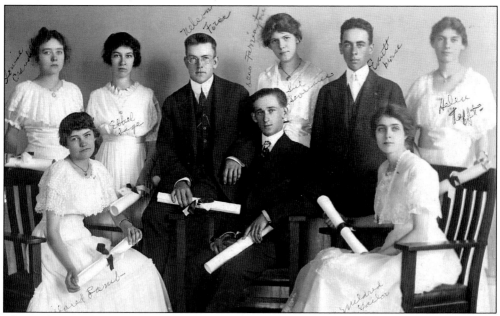

The graduation class of 1915 consisted of nine students. The ceremony took place in the academy hall, which was on the third floor of the Stillwater Union School. Pictured from left to right are (first row) Mildred Lamb, Leslie Farrington, and Mildred Gailor; (second row) Louise Crandall, Ethel Gage, Nelson Force, Susan Severance, Everett Morse, and Helen Tefft.

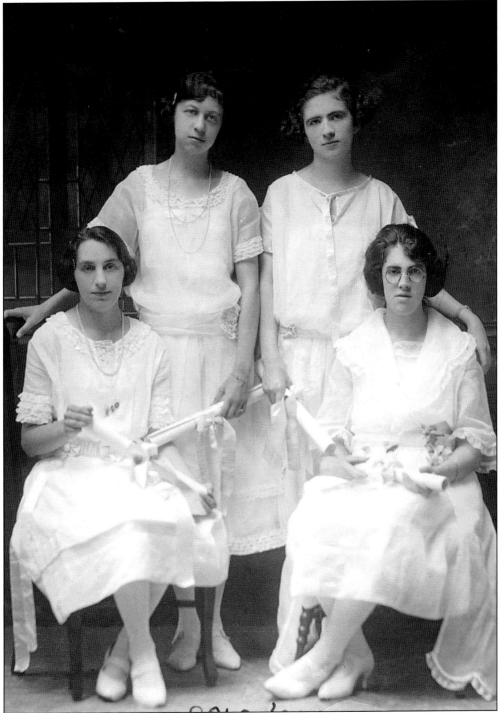

Although there were only four young ladies that graduated in 1922, they went on to greater ideals. The valedictorian was Mildred Van Vranken, and the salutatorian was Kathryn Butler. The class motto was, "Life is what we make it." Pictured from left to right are (first row) Mildred Van Vranken and Bernice Hamilton; (second row) Leila Harden and Kathryn Butler.

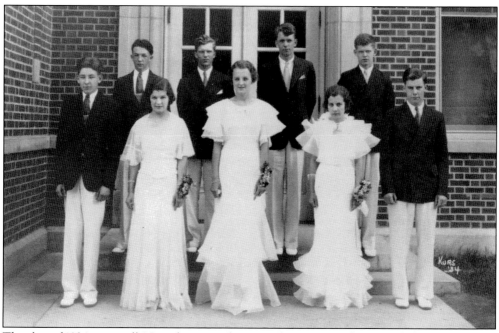

The class of 1934 was small. Note the pretty dresses and corsages on the young ladies and the boys in white pants and white shoes. From left to right are (first row) Norman Yarter, Rita Connors, Rita Fordham, Marjorie Osgood, and Earl Cleaves; (second row) Matthew Joyce, William Mac Arthur, Orrin Bauman, and Vincent Morrissey.

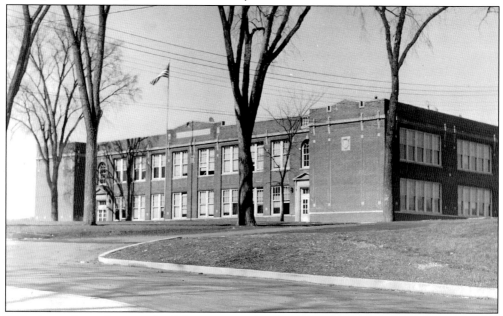

This picture shows the new school that was completed in 1927. This building held the elementary classes on the ground floor and grades 7 through 12 on the second floor. The fast growth of the community brought the need to build another new school. It was completed in 1957. The building was sold to the town and is now the Stillwater Area Community Center. The historian's office is located there.

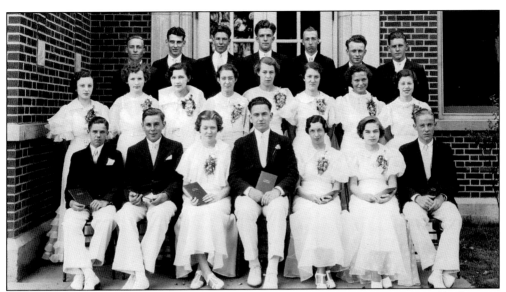

The class of 1936 chose a good motto: "Deeds not words." The valedictorian was Mildred Myers, and the salutatorian was Paul Komoske. From left to right are (first row) Oscar Brundige, Paul Komoroske, Mary Morrissey, William Grady, Dorothy Hoskins, Mildred Myers, and William Scanlon; (second row) Elaine Sedequest, Saraetta Fordham, Arline Cansdale, Alice Wright, Louella Bloomingdale, Helen Hutchinson, Josephine Brown, and Paticia McNany; (third row) Edward Finger, Donald Domack, Casemiro Brown, Ashbel Rogers, Richard Mahar, Francis Reilly, and Ivan Campbell.

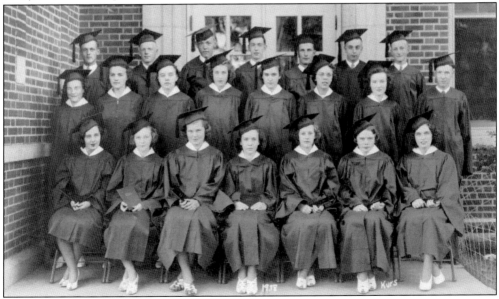

The class of 1938 was the first class to wear caps and gowns. They did it without the principal's knowledge. From left to right are (first row) Jean Bolton, Dorothy Campbell, Jane Flynn, Constance Brown, Jane Longstaff, Rita Britt, and Rita Whalen; (second row) Katherine Finnegan, Helen Moore, Alice Blizzard, Mary Lane, Eleanor Crandall, Florence Lee, Matha Williams, and Frank Smith; (third row) Raymond Pohl, Ralph Wagoner, Laurence Carney, James Furlong, Walter Kardash, Elmer Meyers, and Clifford Schultz.

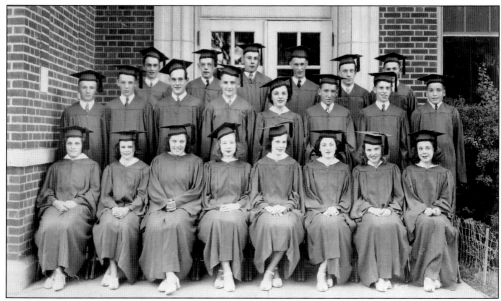

The class of 1940 welcomed the Civilian Conservation Corps to Stillwater. From left to right are (first row) Cathrine Gorsky, Norman Ford, Ednna Gorsky, Helen Carey, Betty Morrissey, Carol Bull, Helen O'Kosky, and Claire Martin; (second row) Paul Ropitsky, Neil Fossett, Daniel Ford, Albert Wagner, Mildred Hayner, Robert Gibeault, Martin Phillips, and Samuel Vega; (third row) Donald Farrington, Dwight Dunn, Harold Komoroske, Albert Cassier, Lewis Chase, and James Brown.

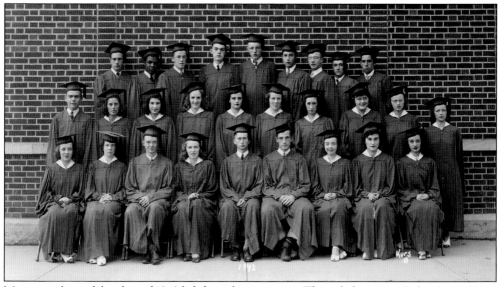

Many members of the class of 1942 left for military service. The valedictorian, Delor Arvin Hart, was killed in action. From left to right are (first row) Cornelia Daly, Jean Britt, Delor Arvin Hart, Doris Osmond, Kenneth House, Edward Tatro, Eleanore Doughty, Virginia Van Vranken, and Elizabeth Perrino; (second row) Bernard Dunnigan, Eva Morby, Isabelle Moll, Sara Burbridge, Joan Fitzgerald, Elizabeth Sheridan, Marie Hanehan, Ilah Kellogg, Grace Moore, and June Gilgallon; (third row) Marshall Pregent, Arthur Dinallo, William Sheridan, William Flatley, Charles Jones, Elton Travis, Marion Rodriquez, Frank Kushnier, and Henry Moll.

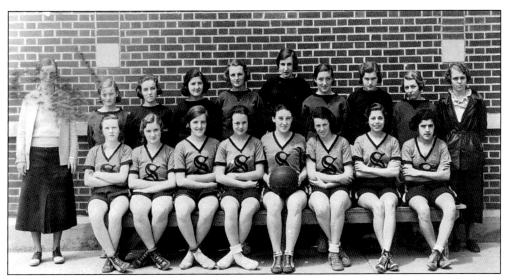

There was a Stillwater High School girls' basketball team during the 1932–1933 season. From left to right are (first row) Jane O'Pray, Sarah Smith, Edna Rogers, Marjorie Scott, Luella Mills, Agnes Doty, Ruth Elliot, and Emma Vega; (second row) coach Helen Coye, Leila Baldwin, Mary Roberts, Jean Wagner, Rita Fordham, Elsie Lane, Evelyn Darrow, Rita Flynn, Ruth Whalen, and manager Annetta Cowin.

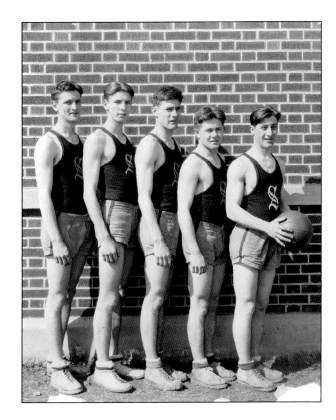

The first year Stillwater High School played basketball in a league was 1930. Those pictured were the first string. From left to right are Truman Whitman, James Brooking, James Nolan, Joseph Lee, and Louis Granger.

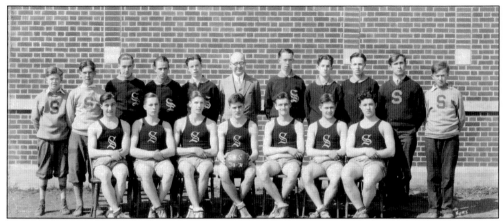

This is a picture of the entire 1930–1931 basketball team. From left to right are (first row) Lewis Granger, Donald Hale, James Brooking, James Nolan, Truman Whitman, Joseph Lee, and Walter Quackenbush; (second row) Vincent Morissey, Herbert Lee, Michael Mohan, William Mattoon, Thomas Williams, T. R. Townley, Russell Bull, Lynn Goodrich, Kermit Smith, L. Smith, and Frank Moore.

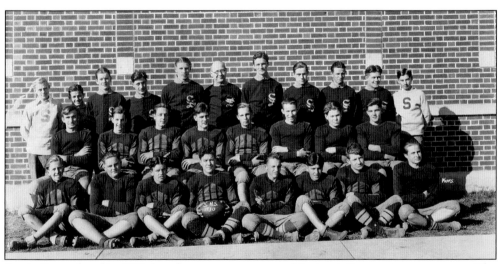

Football was played in 1930, but the team was not noted for its ability to win many games. The first game it played was against the team from Arlington, losing 56-0. Then they improved slightly and only lost to the Cathedral team 19-0.

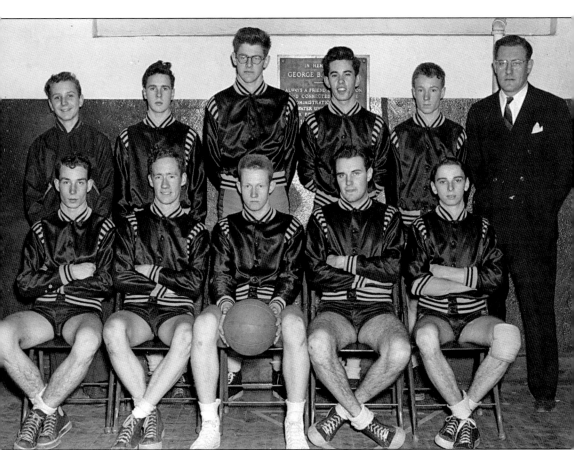

This basketball team was excellent, making it all they way to finals. This was the first team from the new Stillwater Central School. Left to right are (first row) Kenneth Baker, Michael Hanehan, Gerald Brewster, George Cassier, and Thomas Kinisky; (second row) Robert Poitras, William Hunter, Henry Kirby, Robert McClements, Howard Baker, and coach John Murray.

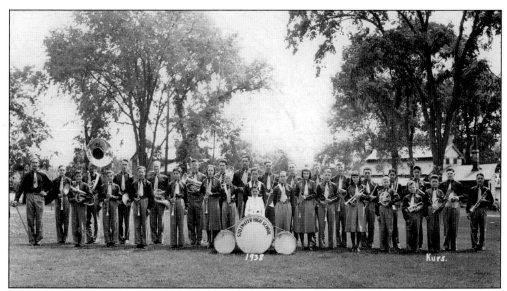

In the 1930s, the high school band from Stillwater was under the direction of C. V. Keuhn. From left to right are Joseph Yanchunis, William Flatley, Marshall Pregent, William Shultz, Edward Tatro, Albert Cassier, Renwick Meyers, Clifford Shultz, Elton Travis, John Bradley, Gladys Wright, James Furlong, William Fordham, Fred Schultz, James Bochetti, Kenyon Robinson, Roy Sharp, John Osmond, Isabelle Moll, Dwight Dunn, Thomas Whalen, John Rentz, Virginia Van Vranken, Warren Lee, Kenneth House, Donald Velie, Raymond Holmes, Gordon Bull, Charles Haight, Martin Gannon, and Harold Dyer, with mascot Thomas Connors standing in the front.

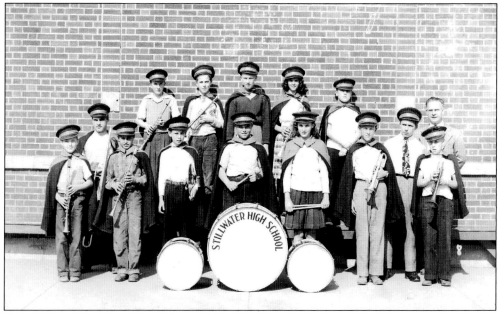

Here is the high school band from 1947. It was small, as it was the last one prior to the centralization of the school. From left to right are (first row) unidentified, Donald Antolick, Russell Thomas, Philip Case, Marie Lane, Richard Rathbun, and Elting Doughty; (second row) Pasquale Capeci, and Ronald Pickett; (third row) John Graves, David Lane, unidentified, Ann Case, Nelson Armlin, and Frank Alexik.

Six

CLUBS AND
ORGANIZATIONS

Montgomery Lodge 504 of the Free and Accepted Masons was reorganized in June 1860. The first Montgomery lodge was one of the earliest in New York State. It folded during the anti-Masonic movement of the 1840s. The first Masonic temple was on Montgomery Place. It later moved to the third floor of the Smith Block. This is a picture of Rev. William Heath, who served as the first master in 1860.

The Pemble building, which was previously the home of William Pemble, was purchased by the Masons in the 1940s. The house was converted into an apartment on the south side. The lodge room was on the second floor on the north side. A kitchen and dining room was located underneath. It was later sold to Alfred Quade in 1953 when the Masons purchased the former Methodist church.

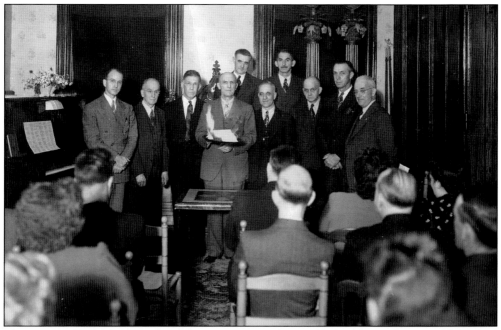

This picture shows the burning of the mortgage of the Pemble building, which was purchased in the late 1940s. From left to right are (first row) Arthur Wilbur, Chauncy Peacock, Rollie Hill, Earl Hayner, Henry Truland, Jay Smodell, Floyd Shorter, and Earle Ward; (second row) Harold Tompkins and Henry Van Vranken.

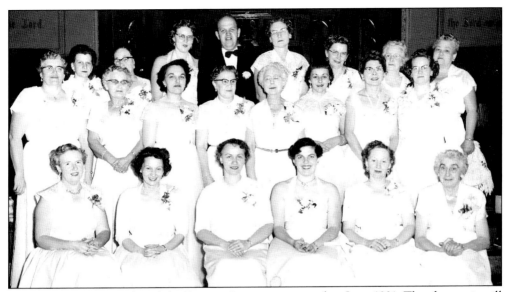

Upton Chapter 679 Order of the Eastern Star was organized in June 1921. The chapter is still active and meets in the Masonic temple in Schaghticoke. The picture was taken in the late 1940s and shows the chapter officers. From left to right are (first row) Ruth Gailor, Carolyn Thomas, Lois Hinkley, Eleanor Gailor, Anna Mae Brewster, and Bessie Farrington; (second row) Winfred Wood, Ilah Kellogg, Mildred Gooley, Margaret Bailey, Ellen Dean, Jane Chuba, June Anderson, and Kathleen Guttridge; (third row) Marjorie Osgood, Bertha Swann, Lorraine Lowell, Clyde Hinkley, Alys Lowell, unidentified, Cordelia Pitney, and Maud Tompkins.

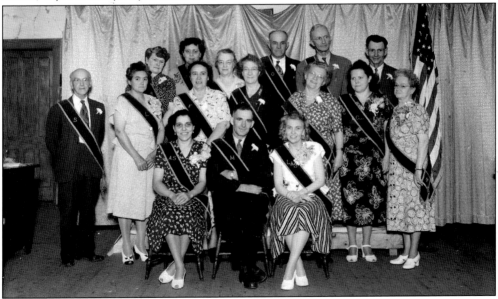

Bemis Heights Patrons of Husbandry 1525 was formed on June 13, 1933, and met in the Grange hall at Bemis Heights. The first master was Jacob Pratt. This picture was taken when Ruth Cowin was master. From left to right are (first row) Leila Birdsinger, William Eaton, and Ruth Cowin; (second row) Lester Sharp, Clara Shultz, Mabel Sarles, ? Hale, Pearl Cowin, Dorthea Crandall, and Addie Kellogg; (third row) unidentified, ? Rocker, Anna Pratt, Carl Shultz, Harry Hale, and Walter Cowin.

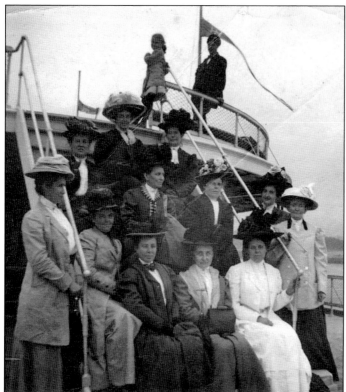

The Village Improvement Society was started in May 1907. The purpose of the organization was to improve the appearance of the village. One of the first projects of the society was the establishment of a village park. On a sunny morning in July of that year, the ladies went forth with brooms and hoes and began their job. By evening, they completed their task and made the village more presentable. Seen here are Mary Bradley, Louise Hudson, Lillian Becker, Jeanette Smith, Adah Handy, ? Stumpf, Elizabeth Newland, Jane Carver, ? Lowe, Anna Deyoe, Cecilia Hunter, and ? Pemble.

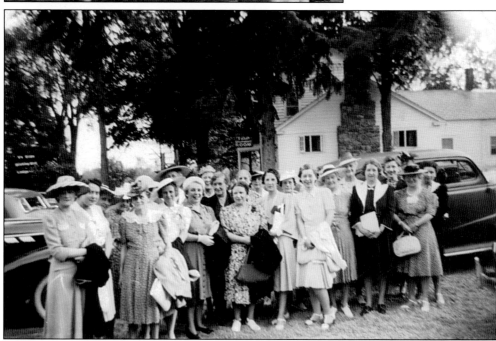

This picture is of a later group after its name was changed to the Stillwater Improvement Society to include the town. The beauty of the community was of the upmost importance to these ladies. This society continued into the late 1970s when it disbanded.

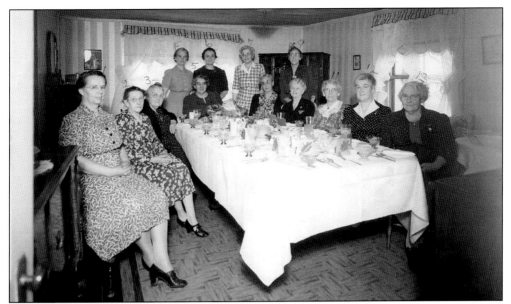

The Stillwater Center Home Bureau was organized on September 20, 1920, by the Saratoga County leader, Lucy Swift. They began with 17 members and later increased to 57 that same year. On November 1, 1944, the members met to disband, and this photograph shows them enjoying their last meeting. Clockwise from bottom left are Agnes Blizzard, Lena Lamb, Mary Farnam, Elizabeth McGraw, Linda Thomas, Alice Poucher, Nina Webster, Bertha McDermott, Maude Handy, Jennie Gorsline, Jessie Gailor, Katherine Mehan, and Rose Baker.

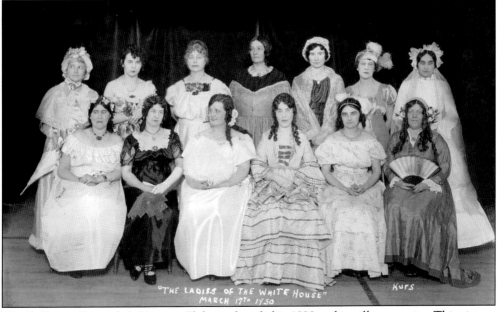

The Stillwater Fortnightly Literary Club was founded in 1898 and is still very active. This picture was taken in 1930 and shows the members dressed as ladies of the White House. From left to right are (first row) ? Grimes, ? McNany, Louella Bolton, ? Barton, unidentified, and Addie Ward; (second row) Mary Sullivan, unidentified, Ellen Dean, ? Hale, Dorothy Redmond, Hilda Wilbur, and Mary Smith.

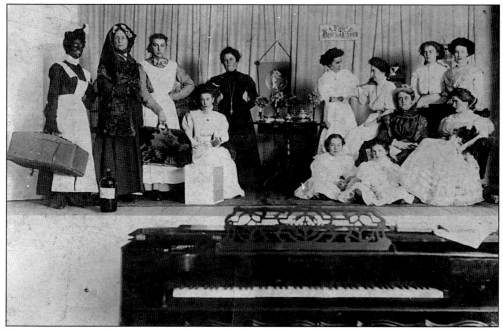

This is a picture of a very early theatrical play, *A Visit of Obediah*, which was presented on March 17, 1909. Identified here are May Church, Mae Ward, Sarah Pemble, Ida Curtis, Helen Taylor, Ella Tucker, Bessie Van Vranken, Hilda Smith, Elizabeth Newland, Alice Hudson, and Ethel Nelson.

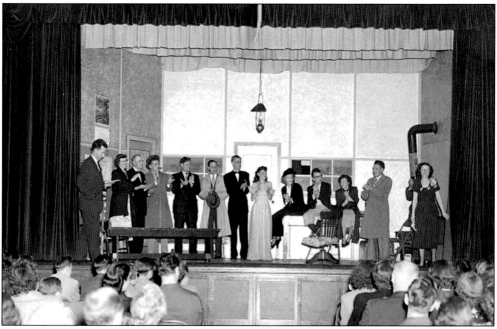

The Stillwater Dramatic Club was formed in the 1940s. This production was titled *The Ghost Train* and was performed in 1950. The cast, from left to right, are William Sheehan, Elizabeth Neilson, Clarence Bull, Albert Wagner, Bill Bugli, Christopher Martin, Raymond Nelson, Frances Tanner, Marie Evans, John Mohan, Jane Page, Robert Gibeault, and Leisetta Rodriguez (director).

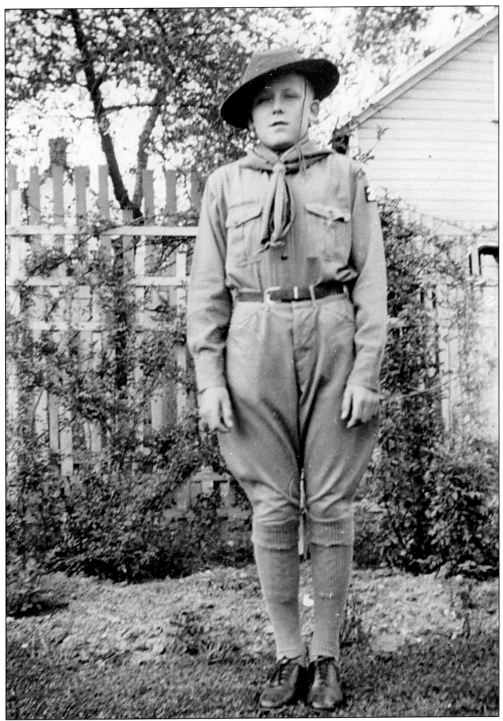

Boy Scout Troop 35 has been in existence for many years. It is still very active in the community. This picture shows Leo Barbolt, who was a member in the 1930s. The uniform was surplus from World War I. (Courtesy of Leo Barbolt.)

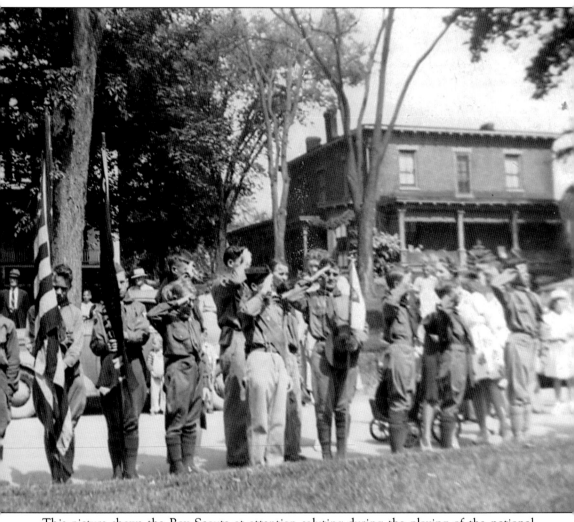

This picture shows the Boy Scouts at attention saluting during the playing of the national anthem. The Memorial Day parade is still a big event, and the entire community participates, especially the scouting groups. (Courtesy of Leo Barbolt.)

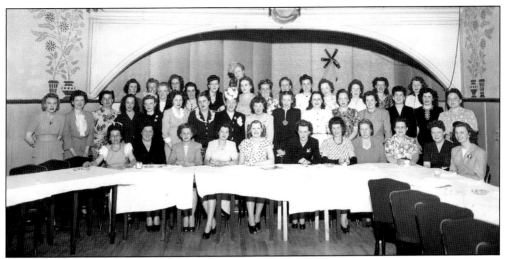

There were several bowling leagues in Stillwater. Men's, women's, and mixed leagues were very popular. This picture was taken in the 1940s. From left to right are (first row) six unidentified, Leone Cook, Lillian Mitchell, Elizabeth Thomas, unidentified, and unidentified; (second row) Ruth Coran, Edna Sykes, Anna Mae Rose, Rosemary Leftner, unidentified, Constance Messore, unidentified, Marian Maby, ? McKenzie, Mary Hunt, Dorothy Thomas, Leila Baker, unidentified, Magaret Quinn, Helen McGurie, Mary Boucher, and Margaret Walsh; (third row) Marie Marsh, unidentified, Elieen Foley, unidentified, Janette Haney, unidentified, Frances Vahan, Judith Jones, unidentified, Mary Covotta, Doris O'Connor, ? Leylend, unidentified, and Ena Benham; (fourth row) Anna Daley.

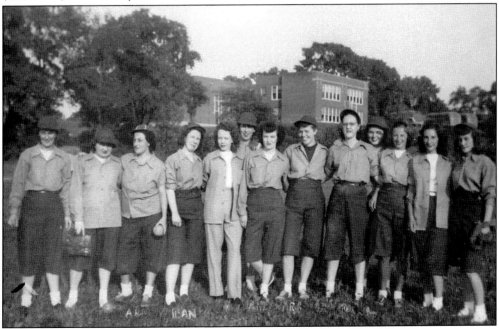

Softball was popular in Stillwater, and this team was sponsored by Milton Carter, a local businessman. They were the champions in 1948. From left to right are Ida DeCelle, Florence Connor, Anna Caruso, Jean Britt, Mary Stewart, Edna Campbell, Jane Gibeault, Marjorie Gailor, Eleanor Carter, June Patterson, Mary Wilkes, Angela Russo, Frances Tanner.

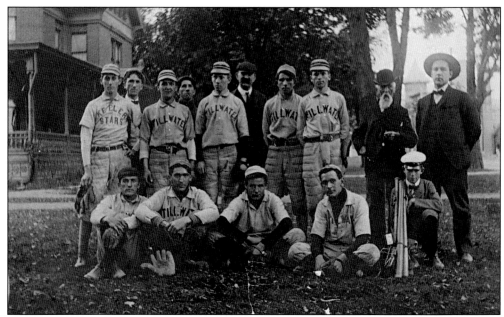

This baseball team was one of many in the area. They played at Mitchell Field near the Riverside area. From left to right are (first row) Earl Hayner, Thomas Underhill, Meridith Carver, Archie Hinman, and Walter Smith; (second row) unidentified, Fred Hayner, Willard Barker, Edward Britt, Michael Mahoney, unidentified, and Frank Tucker (manager). All in the third row are unidentified. This picture was taken on John B. Newland's lawn.

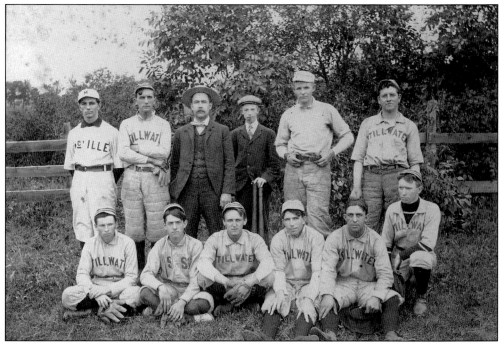

This picture was taken about 1906. From left to right are (first row) Michael Mahoney, Archie Smodell, Fred Hayner, Edward Britt, Frank Reilly, and Willard Barker; (second row) unidentified, Earl Hayner, Frank Tucker, Walter Smith, Meredith Carver, and Edward Hickey.

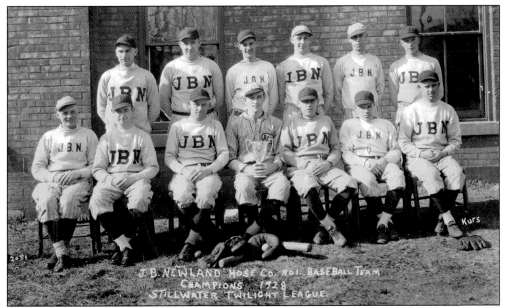

In 1928, Stillwater residents formed a twilight baseball league; they were the champions. This is a picture of the J. B. Newland Hose Company No. 1 baseball team. From left to right are (first row) Walter Quackenbush, Lloyd Goodrich, James Hutton, Edward Sheridan, Harry Bloomingdale, ? Hurd, and ? DeCota; (second row) Purcell Brownell, Percy Aldrich, Fred DeCota, Harry Cisler, Albert Bloomingdale, and Harold Whalen.

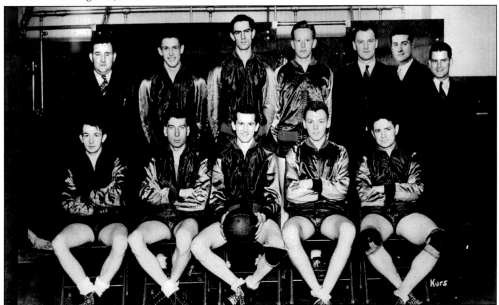

The Collegians were a semiprofessional basketball team from 1936 to 1943. Percy Aldrich was the originator and team manager. For 50¢, one could watch two games at the high school gym. World War II brought a halt to the team. From left to right are (first row) Matthew Joyce, Francis Carroll, William Daley, Laurence Carney, and Benjamin O'Connor; (second row) Percy Aldrich, Carl Barney, George Toombs, Hollis Deso, Truman Whitman, unidentified, and Karl Hickey. (Courtesy of William Sheehan.)

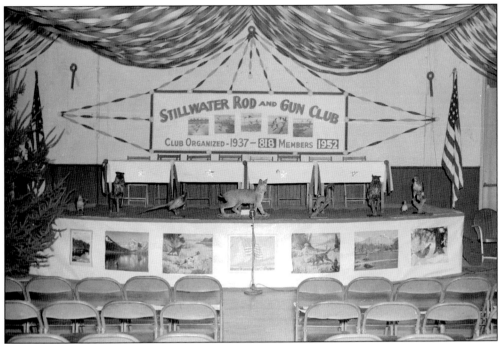

The Stillwater Rod and Gun Club was formed in 1936. It purchased land in the town of Easton in 1951 for its activities. It is still active and noted for its wonderful clam steams. This picture shows where one of the yearly banquets was held on the third floor of the Moosehead Inn.

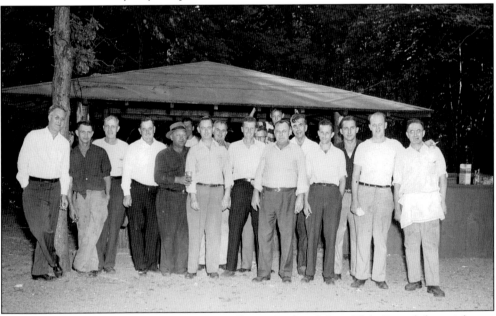

This is a group picture of members of the Stillwater Rod and Gun Club. From left to right are (first row) Floyd Travis, Walter Cowin, ? Marshall, unidentified, Chester Bloomingdale, Lynn Goodrich, Clyde Hinkley, and Marion Rodriguez; (second row) Clarence Bull, unidentified, Roy Sharp, Llyod Goodrich, John Hammond, Huge Bryan, and unidentified, with young Thomas Walsh standing behind.

The Gradatim Club of the First Methodist Church was a group of ladies who met monthly. This picture was taken about 1920. Identified here are Ethel Sage, Bessie Kellogg, Adah Farrington, Ida Curtis, Laura Peacock, Edna McClenithan, Isadora Palmer, Bertha Knibbs, Ida Sage, Dora Dyer, ? Spohn, Susan Severance, Edna Gray, Maude Bradley, Edna Schoonmaker, and Anna Yarter.

The Philathea class of the Second Baptist Church was a group that met monthly. They also had social outings, and this picture was taken at one of them. Identified here are ? McNabb, ? McNabb, Cordelia Pitney, Kenneth Vandenburgh, Sila Anthony, ? Dyer, Mae Osgood, ? Pitney, Bessie Vandenburg, Lena Rowley, Edith Haight, ? Hoskins, Pauline Osgood, Mary Belle Palen, ? Haight, and Ellen Dean.

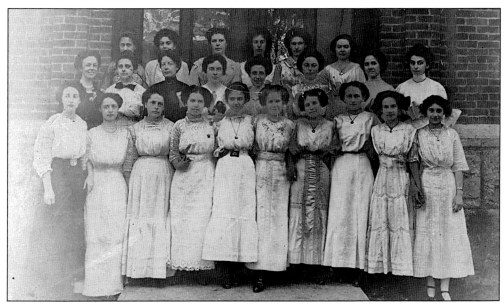

This is a group of young ladies from the Second Baptist Church about 1910. From left to right are (first row) Cordelia Pitney, Clara Walker, Sila Antony, Lucile Neilson, Metta Smith, Lucy Martin, Ruth Hoskines, Ilah Kellogg, Hazel Osgood, and Alice Martin; (second row) Helen Scott, Alice Smith, Emma Wood, Celia Hunter, Clara Smith, Alida VanVranken, Florence Smith, and Bessie VanVranken; (third row) Hilda Smith, Maude Bradley, Marian Lawrence, Alive Morse, Bessie Farrington, and Ella Barker.

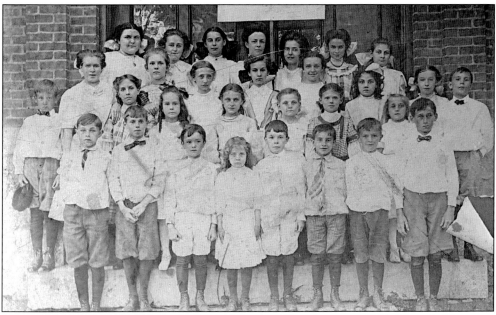

This is a group of children from the Second Baptist Church around 1900. Identified here are Lyman Smith, Dayton Case, William Pemble, Edna Osgood, James Church, Harold Smith, David Dyer, Leslie Farrington, Lucy Martin, Leone Bradley, Ruth Burrette, Irene Osgood, Helen Case, Susan Severance, May Church, Ruth Smith, Ilah Dyer, Helen Scott, Leone Smith, and Helen Osgood.

Seven

TRANSPORTATION

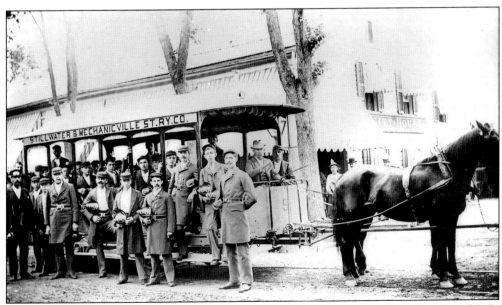

This picture was taken on July 4, 1895, and shows the firemen of the E. I. Wood and J. B. Newland fire companies of the Stillwater Fire Department. They were on their way to a firemanic muster in Mechanicville. The streetcar was from the Stillwater and Mechanicville Street Railway Company.

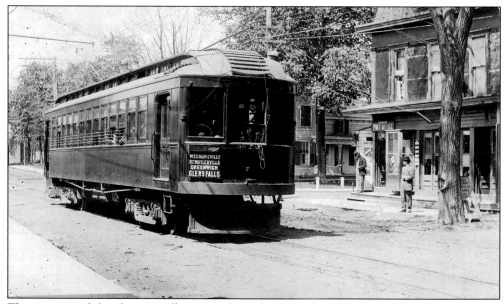

This is a one of the electric trolley stops along the route from Mechanicville. The owner was the Hudson Valley Railway Company. There probably were a number of men in the smoking car discussing many subjects like the recent trolley strike, the end of World War I, or women getting the right to vote.

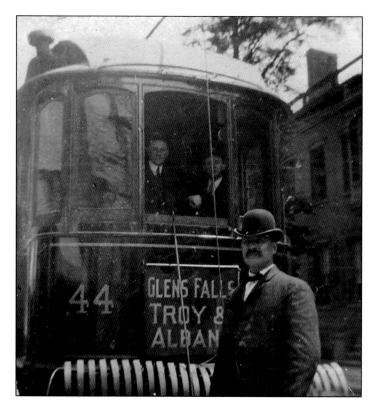

Charles Dyer was one of the conductors of the trolley. He is pictured here at a stop. The trolley brought modern transportation to the people of the area. There were six cars travelling regularly each way between Stillwater and Mechanicville. The cost was 10¢.

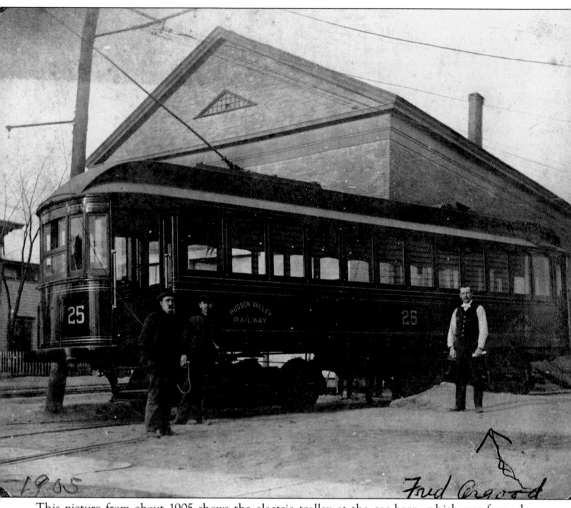

1905

Fred Osgood

This picture from about 1905 shows the electric trolley at the car barn, which was formerly known as the Session House. It was located on Hudson Avenue where the parish center is now. This was where the trolleys were repaired, equipment was maintained, and cars were stored. Fred Osgood (right) is pictured here with two unidentified people.

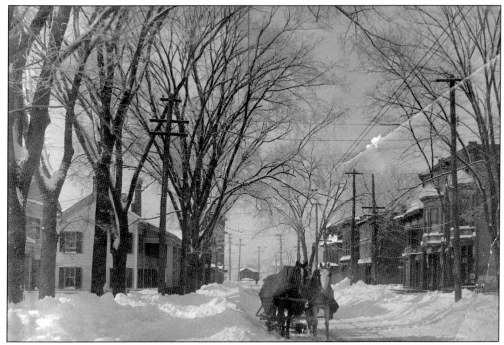

This horse and wagon with runners was a popular mode of transportation in the winter. This picture shows Main Street, now known as the Hudson Avenue. The building on the far left is the Hewitt House; it no longer exists. The buildings on the right are still there and are in use.

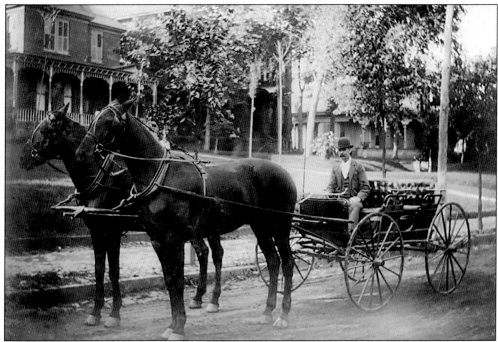

This beautiful horse and carriage was a means of transportation. This picture was taken on Main Street near Lansing Road. Note the matched pair of horses. They probably belonged to one of the more prominent residents of Stillwater. The gentleman driving is unidentified.

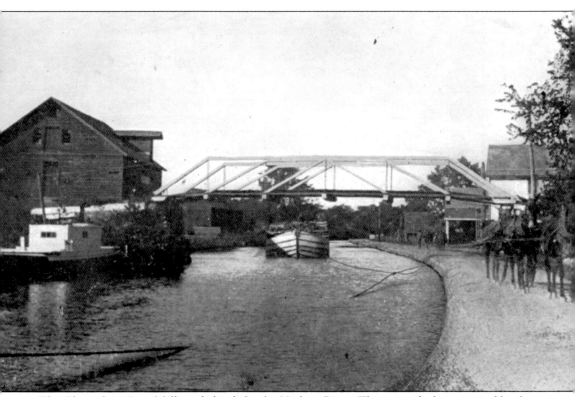

The Champlain Canal followed closely by the Hudson River. The towpath that was used by the mules to pull the barges is still visible in part of the town and village. This picture shows them pulling a barge near where Neilson Avenue is in the village.

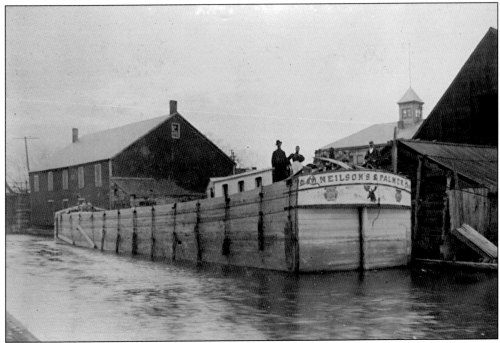

This barge was owned by William Neilson and was used to haul freight up and down the canal. His partner in business was Ephraim Newland, a prominent mill owner. This was called the potato boat, as it brought fresh vegetables down the river to New York.

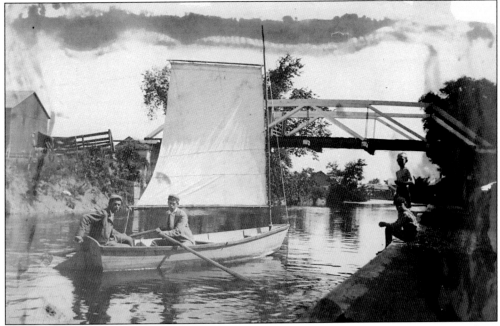

The canal was used not only for business but also pleasure. This picture shows two young boys enjoying their boat. Many bridges went across the canal, so people were able to get to their homes, especially the farms in the countryside. The saying, "low bridge every body down," came from the canal people.

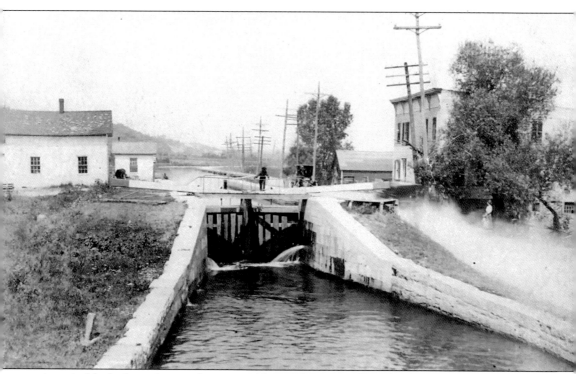

A typical lock along the canal is pictured here. They were all made of wood and were opened by hand. The locks were hard to maintain, as they were subject to rotting and leaks beneath the stones, causing silt and debris to lower the depth of the water. This one was a lock that was located near Stillwater.

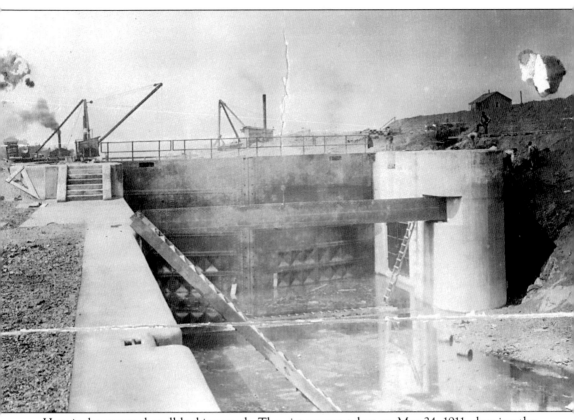

Here is the approach wall looking south. The picture was taken on May 24, 1911, showing the lock nearing completion. The huge doors were in place, and the final work had begun. This is the same lock that is still present even though there have been updates.

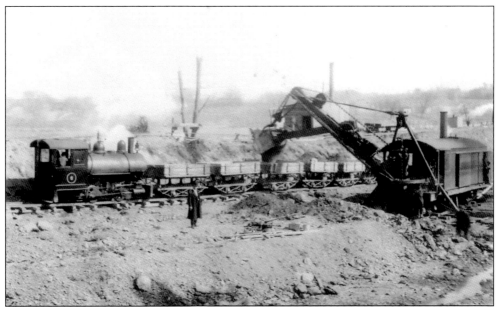

This photograph shows the progress of the digging of the canal in June 1910. A steam shovel works on the prism south of the lock. This view looks west between Green and Parry's Island.

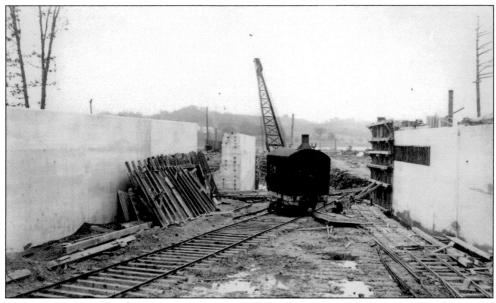

This picture shows the final preparations to install the gates. This was done in 1911. The cost of these gates was $46,200, determined at 6¢ per pound with a total weight of 770,000 pounds. The steam shovel is working on the last stage.

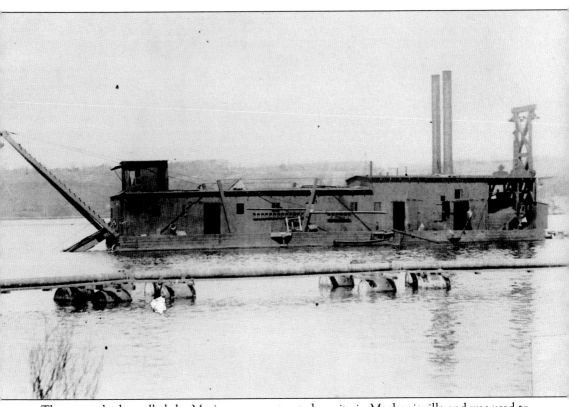

The steam dredge called the *Marion* was constructed on site in Mechanicville and was used to deepen and widen the channel between lock three and lock four. The distance between the two locks is two miles. It is unknown how deep the channel was made.

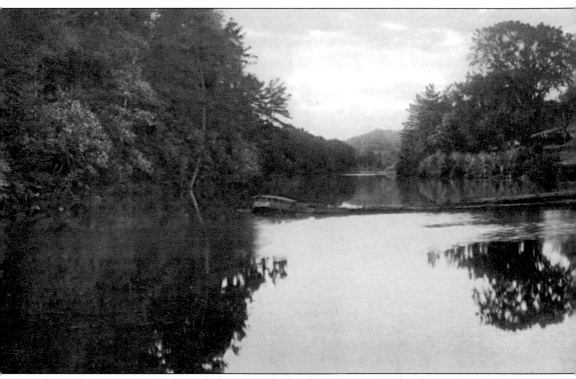

The Hudson River winds through the area called Wilbur's Basin, which is located on the border with the town of Saratoga. It was in this area that Gen. John Burgoyne and British and Hessian troops came at the time of the Battles of Saratoga in 1777. The serenity of the river attracts many birds and other wildlife, especially deer that come from the park to drink the coolness of the water.

Years ago, there were a number of large four-by-eight-foot piers with two holes for power poles along the river and sometimes a little further inland, where power was transmitted to various locations along the trolley lines. These metal wheels can be found at the Blockhouse Park as an exhibit at the north end.

Schuyler Creek, which now flows directly from the Hudson Avenue bridge to the river, used to swing westward before entering the Hudson River after passing up river about 50 yards through the waste pond (a pond where water was wasted after having generated power) from the Hudson gristmill. This was the first attempt to reduce the problems with ice jams at the end of the creek. Further work was done in the late 1940s or early 1950s to alleviate the ice-jamming problem. During this later work, a power transmission pier along the west side of the creek was buried and still lies somewhere in the mud, according to Thomas Walsh.

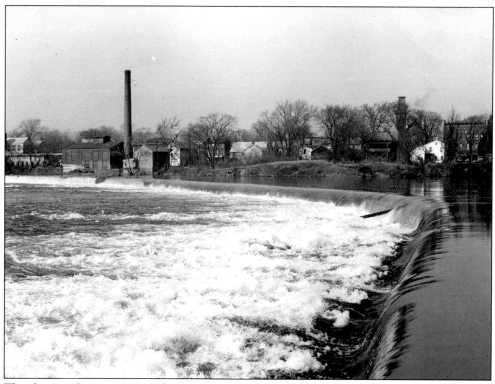

This dam on the river was used to generate electric power for many years. This power was used in the mill along with the electric trolleys. A new power plant came to the village in the early 1990s and continues to be used.

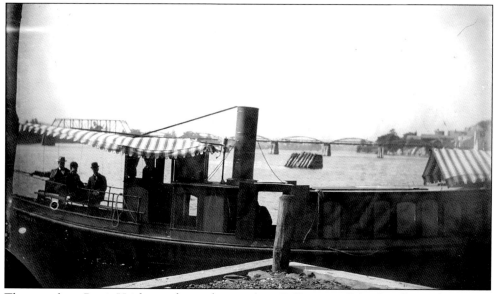

The steamboat *Bemis Heights* used to make trips from Stillwater to Schuylerville on the river in the 1890s but was abandoned after the electric trolleys went through. This picture was taken at the steamboat dock at the front of Schuyler Lane. The old iron bridge is in the background. The little boat was gay with awnings and had a very loud shrill whistle that scared little children.

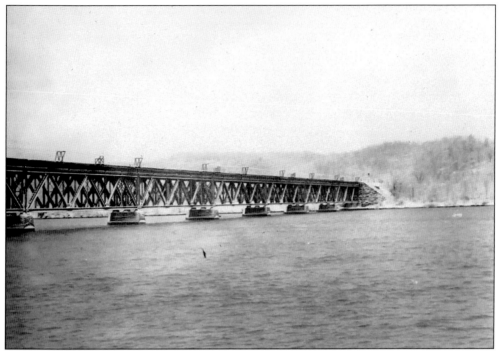

The railroad bridge going across the Hudson River has two sets of tracks. This was one of the significant rail canters that were developed in the 19th century. To this day, freight is hauled to parts of New England over this bridge. The Boston and Maine Railroad used to own the tracks. They are now owned by Guilford.

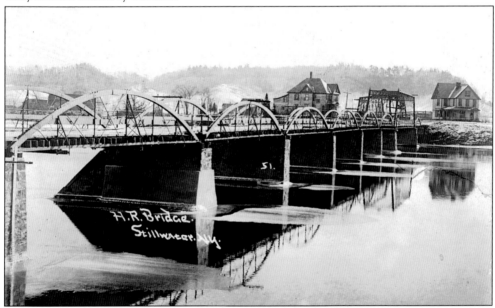

The bridge in the village goes across the Hudson River and connects to where the New York State Barge Canal System is located. This postcard shows the one built in the late 19th century, when the barge canal was begun. Note that the house on the right was later purchased by the state and razed.

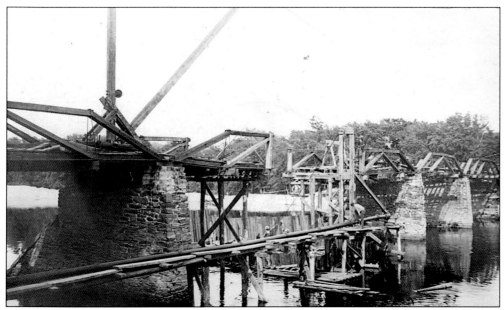

When the New York State Barge Canal System was being built, a new bridge was also erected. These two postcards show the construction, with the building of the piers for support. This leads to the Stillwater Bridge Road, which went into Rensselaer County and the town of Schaghticoke. The original flooring was wooden but was replaced in the 1930s by metal and asphalt. There have been repairs and replacements through the years, the last being in the 1980s.

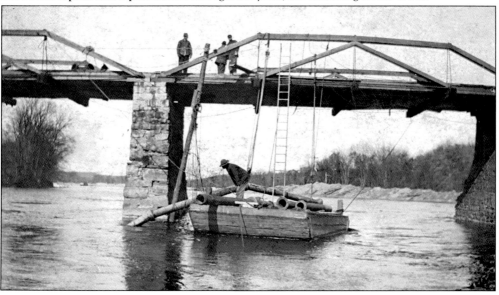

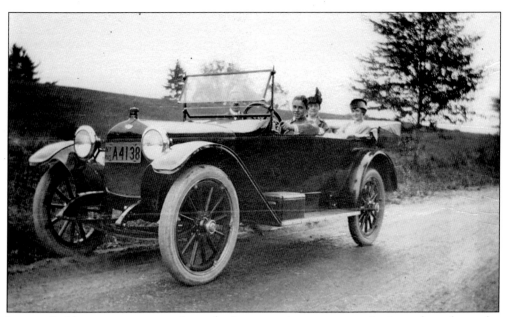

Lyman Smith was a very prominent businessman in many organizations throughout the community. During the 1920s, he was known as a "swell." He had many fancy cars, including this one. He is pictured driving with his parents and his wife, Mary, behind him.

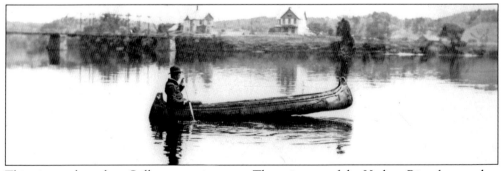

This picture shows how Stillwater got its name. The quietness of the Hudson River here makes it an ideal place for fishing and recreation. The gentleman in the canoe is William Moore, who was noted for paddling back and forth along the river. This was taken prior to the New York State Barge Canal System being built, as it shows just the one bridge going over the river.

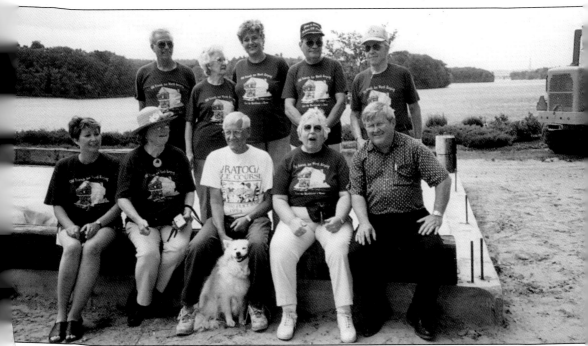

The Stillwater Blockhouse Committee came into existence in November 1991. This is a picture of the original committee taken on June 3, 1999, the day the blockhouse was moved to its site in the village. From left to right are (first row) Jo-Ann Winchell, Eileen Gannon, Jack Lenihan, Linda Sanders, and supervisor Paul Lilac; (second row) Ross Clothier, Helen Joslin, Linda Palmieri, Mayor Ernest Martin, and Harold Joslin. Missing from the photograph are Joan Ronda, Kathi Blinn, Robert Becker, and Florence Hanehan. One of the best kept secrets in the village was the hydroelectric plant that was being built. Part of the plan was to provide a green space for the village. The idea of moving the former visitor center of the battlefield to this spot was an exciting possibility.

DISCOVER THOUSANDS OF LOCAL HISTORY BOOKS FEATURING MILLIONS OF VINTAGE IMAGES

Arcadia Publishing, the leading local history publisher in the United States, is committed to making history accessible and meaningful through publishing books that celebrate and preserve the heritage of America's people and places.

Find more books like this at
www.arcadiapublishing.com

Search for your hometown history, your old stomping grounds, and even your favorite sports team.